Sketch Your Stuff:

200 Things to Draw
and how to
Draw Them

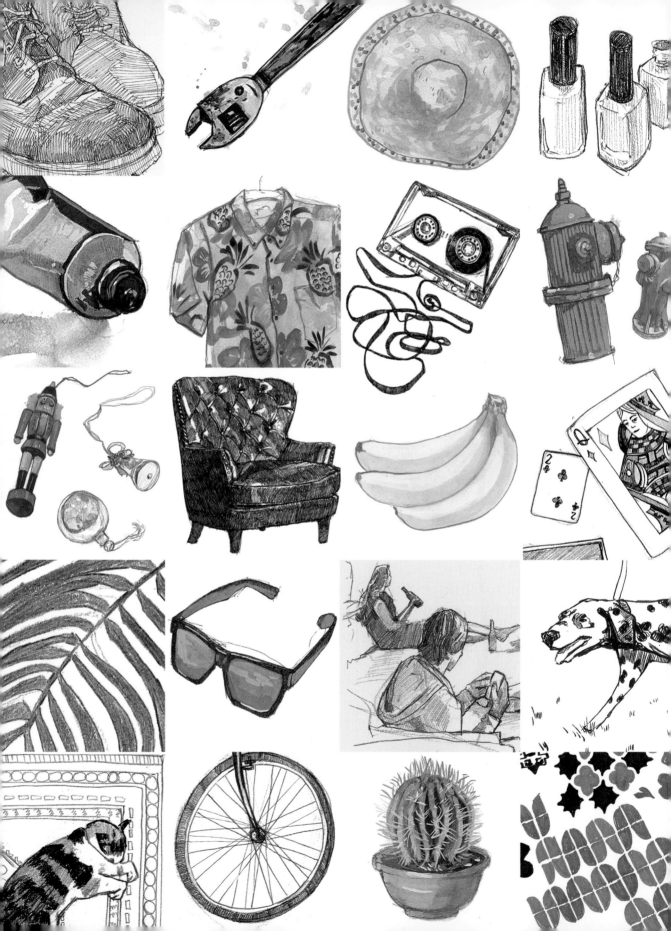

Sketch Your Stuff:

200 Things to Draw

and how to

Draw Them

Jon Stich

Search Press

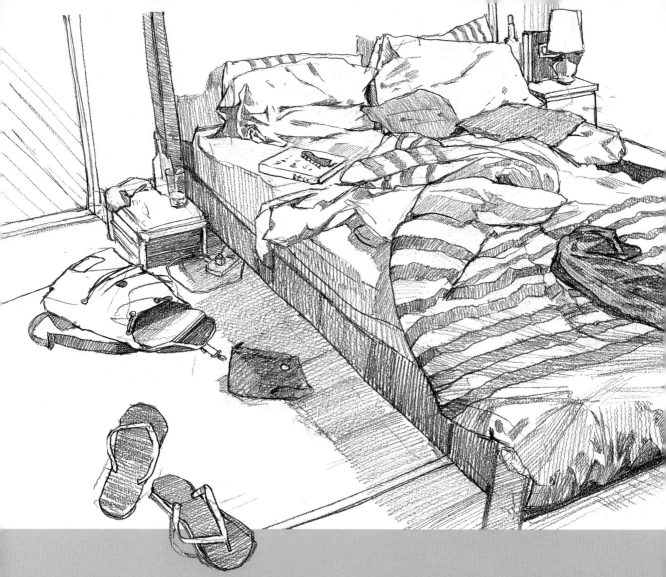

Sketch Your Stuff
A QUARTO BOOK
Copyright © 2017 Quarto Inc.

First published in 2017 by
Search Press Ltd
Wellwood
North Farm Road
Kent TN2 3DR

Conceived, designed and
produced by
Quarto Publishing ltd
The Old Brewery
6 Blundell Street
London N7 9BH
www.quartoknows.com
QUAR.DADY

ISBN 978-1-78221-514-1
10 9 8 7 6 5 4 3 2 1

Senior editor: Chelsea Edwards
Designer: Karin Skånberg
Copy editor: Sarah Hoggett
Proofreader: Emma Hill
Indexer: Helen Snaith
Art director: Caroline Guest
Creative director: Moira Clinch
Publisher: Paul Carslake

Colour separation in Singapore by
PICA Digital Pte Ltd.

Printed in China by 1010 Printing
International Ltd.

Contents

In the
Studio
Page 18

In the
Kitchen
Page 44

3

In the
Bedroom
Page 72

5

In the
Lounge
Page 108

4

In the
Bathroom
Page 94

In the
Garage
Page 126

In the
Street
Page 142

WELCOME TO JON'S WORLD

I have been drawing since I was about nine years old when my father would take me to the local Red Lobster restaurant and I would scrawl all over the menu. I'd draw superheroes, monsters destroying cities, googly-eyed people with contorted legs and arms – whatever popped into my head. My parents have a scrapbook of my earliest art, and nearly all of it was created on the backs of paper menus, on maths tests, on basically every piece of paper that was intended for something other than drawing. I am lucky enough to have parents who supported this habit, because most other adults in my life did not encourage such behaviour. It's true that some of the drawings were crass, and most were created in an environment where my focus should have been elsewhere, but the fact that I worked on my art every single day is how I got to where I am.

I currently work as a freelance illustrator, and a teacher, and I firmly believe that by finding time to draw frequently is the number one way to improve your skills. I'm well aware that time is tough to find, and so is motivation, so in writing this book I've tried to find ways to move past those stumbling blocks to create exercises that aren't time-consuming, and are based on subjects you pass every day.

Whether you're drawing for relaxation or to really improve your skills, look at this book as a way of establishing the good habits of an everyday sketcher!

THE JOY OF SKETCHING

Art-making is an activity that should be incredibly fun, rewarding and therapeutic, but there are some occasions where the process is not quite so serene.

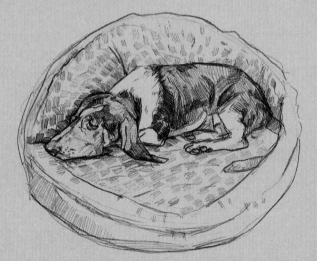

Every time we begin a new piece, we have a vision of it in all its finished glory – but we put this vision on such a pedestal that sometimes it's difficult to attain. Sometimes it's within the first few lines that we fall out of love with our masterpiece, and sometimes it's after churning away for over an hour. My goal with this book is to show you how to break through those barriers, and to truly enjoy the journey from start to finish by learning how to improve your sketching skills.

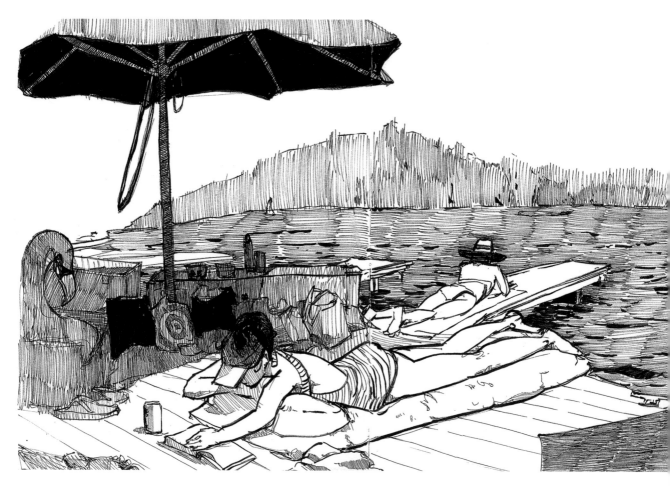

Sketching while you're on holiday is great because everything slows down. You're more relaxed and if you're drawing figures, they're more likely to be still for a good amount of time. Take your journal wherever you travel, and find a place to sit and sketch for as long as you want.

One of the main reasons that sketching is a helpful way to grow is that there is much less pressure to display your final piece. This book is about how to make your sketching journal into whatever you want it to be. That means some pages can be your masterpieces, some pages can be a complete mess, some can be a grocery list with random drawings of skulls along the edges. Additionally, sketching in your journal means you can bring it with you on the go, and sketch every single day.

The other challenge is a big one – and that's the always intimidating question of 'what to draw?' So this book is based entirely on stuff that you own and see at home or in your town.

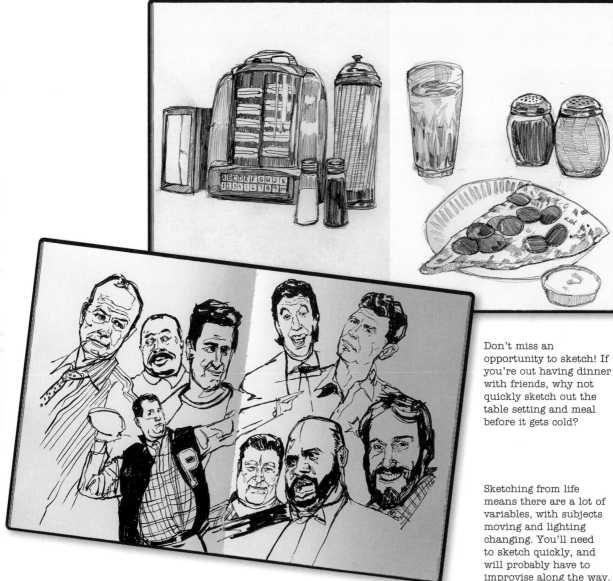

Don't miss an opportunity to sketch! If you're out having dinner with friends, why not quickly sketch out the table setting and meal before it gets cold?

Sketching from life means there are a lot of variables, with subjects moving and lighting changing. You'll need to sketch quickly, and will probably have to improvise along the way.

My favourite analogy is that building a drawing is a lot like building a house: you need to start with a solid foundation. We'll look at objects as simple as a cylinder and as complicated as the human skull, and break down how to work from their foundations to the specific details that make each object unique. This, I think, is the biggest key to overcoming your fears and becoming a better draftsperson.

Pencil

Swirling marks, achieved with hard pressure at first, loosening at the end.

Smooth shading – the lines criss-cross in direction, but don't overlap.

Denser shading, applying more pressure with a slightly worn-down pencil tip.

Cross-hatching – the closer the marks, the darker the shading.

Subtle value differences, created by applying less pressure.

TOOLS OF THE TRADE

You'll need some basic tools to start off with, and I've made sure that you can keep all of them in a small bag that's easy to travel with.

You'll need a 2B pencil, which is a good grade because the marks you make won't be too dark (size B gets progressively darker and softer) or too light and hard (H gets lighter). You'll want some fine-point pens; I usually have about five or so at any given time, usually with a point around 0.5 millimetres and slightly higher. (You never need to press down hard with a pen like this, as you'll always get a fine point.)

You'll want a brush pen, usually one with a fine or medium point, which is a great

Brush pen

A fine line, achieved by just touching the tip down on the paper.

A tapering line, created by applying pressure and then gradually lifting the brush.

Quick, dotted strokes created by holding the brush at an angle and then stippling – great for foliage.

Large, scattered marks, made by pressing the brush down straight onto the page, then quickly dragging it off.

A thicker zig-zagging line, achieved by applying more pressure and moving the brush slowly.

Fine-point pen

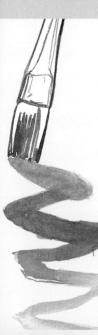

A solid contour line, consistent in weight throughout.

Hatching marks that don't overlap – great for shadow areas.

Curvy marks, made with a looser grip on the pen – good for more organic-looking renderings.

'Stippled' dots – vary the density to control shading.

Cross-hatching – a good way to build up darker values.

tool for creating variations in line quality, as well as for solid shading. And you'll need a few paintbrushes, starting with a couple of flat brushes and a couple of round ones, none larger than an inch.

Choosing your drawing surface

The tools you use are of utmost importance to the work you make. Obviously that includes the mark-making tools you hold, but also consider the surface you draw and paint upon. A more rigid, cold-pressed surface is suited for work in pencil and watercolours, and a smoother, hot-pressed surface is ideal for pen and coloured marker drawings. For the work done in this book, I went with a journal of thicker, cold-pressed paper so that I could use all of the tools I've listed. I made sure the paper didn't have too much tooth (texture), otherwise it would destroy the tip of the pen.

Paintbrushes

A drybrushed stroke with no water, which gives the mark more edges.

A stroke with some water, but fairly thick paint – you can see build-up of the pigment on one side.

A stroke containing a lot of water, giving it the appearance of a bluish filter over the white paper.

Fine marks and crisp edges, created by using a flat brush on its side.

A soft-edged shape, made by applying water first and then dropping in colour.

Painting is an interaction between colour and light. All of the colours in your palette should be linked, and should cross over each other in patterns similar to a Venn diagram. This way, every new colour that you mix will contain some of the tone from its predecessor.

Mixing colours can be one of the most challenging tasks for an artist, as there are an impossibly large number of variables at play.

MIXING THINGS UP

So let's make things a little more formulaic to begin, and learn the basic principles of colour mixing by creating some grids. To make things simpler, limit your palette to just four tubes of gouache paint: cadmium yellow medium, cadmium red medium and ultramarine blue (your three primary colours), plus titanium white. Try to make the paint as opaque as possible, so that you see the true colour you've mixed and not the white of the paper.

Primary colours

Start with the primary colours of red, yellow, and blue, and mix white into each one until you get to solid white in 10 steps. Try to note how much or how little white you need to add to change the colour.

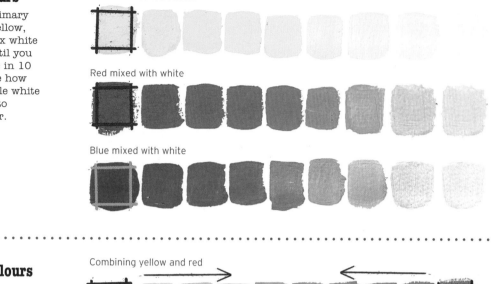

Yellow mixed with white

Red mixed with white

Blue mixed with white

Secondary colours

Now mix secondary colours by combining two primaries. As you mix the two colours together, you'll find the secondary colours of orange, green and violet at the halfway point of each scale. Once again, notice how much or little you need to add of each colour to alter it.

Combining yellow and red

Combining yellow and blue

Combining red and blue

Tertiary colours

Mixing secondary colours together creates tertiary tones. They may seem drab at first, but these are the most organic and natural-looking tones, often used in plants, on flesh and in landscapes. They may get dark as you mix, but try adding white or yellow to brighten them up and see their various hues.

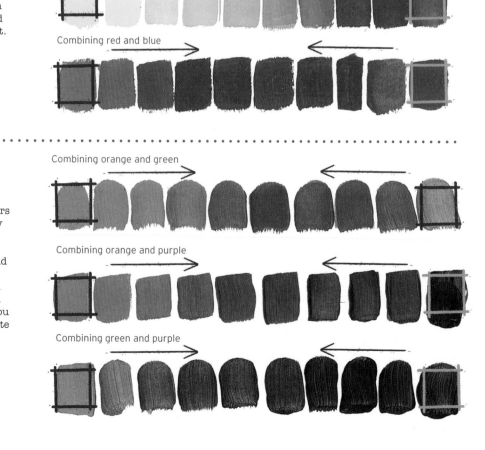

Combining orange and green

Combining orange and purple

Combining green and purple

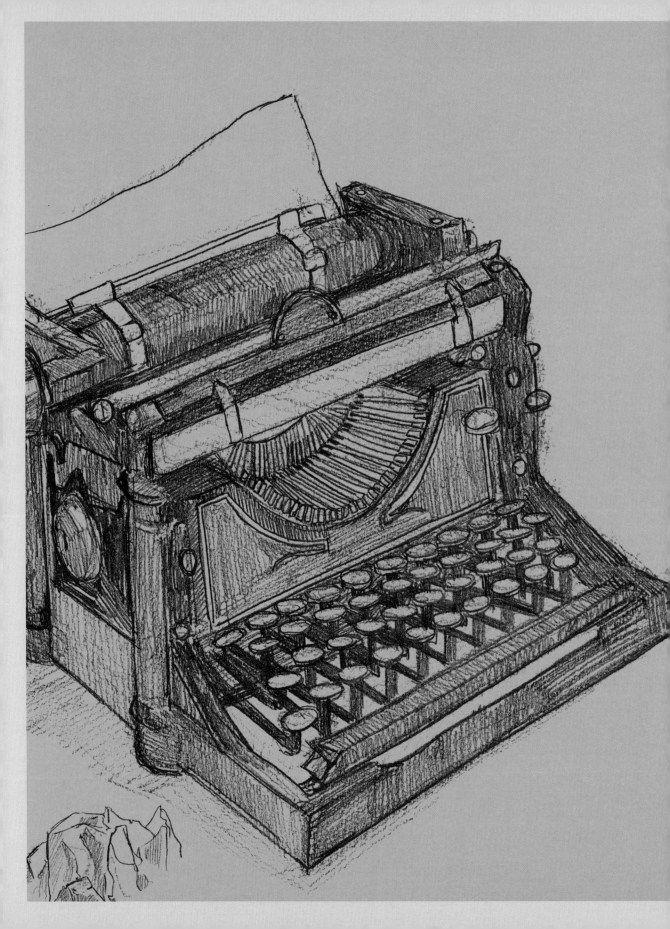

In the Studio

Your workspace is where the magic of art-making happens, but it's also filled with plenty of inspirational objects. Whether your studio is tidy or catastrophic, we'll find plenty of subjects.

Seeing Shapes

Sometimes when figuring out the composition of a still life, it's best to think in ways that are outside the box, so to speak. Rather than zeroing in on each object, try to focus on the overall shape they create, or the negative space around them. Try thinking of this as an exercise in which the objects you're sketching are blocking a projection of light, so the only thing you see is their silhouette.

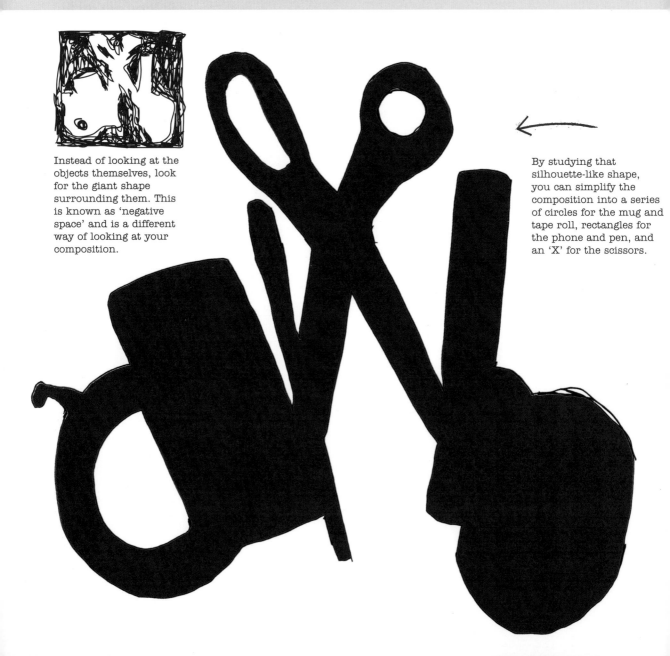

Instead of looking at the objects themselves, look for the giant shape surrounding them. This is known as 'negative space' and is a different way of looking at your composition.

By studying that silhouette-like shape, you can simplify the composition into a series of circles for the mug and tape roll, rectangles for the phone and pen, and an 'X' for the scissors.

DRAW
THIS
No 001

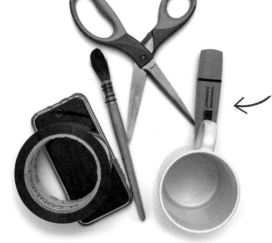

Grab several objects from your drawing area and lay them out on a clean surface in a random fashion, with each object overlapping another, so that you're creating one giant shape.

Make these beginning lines fairly sketchy, and then build into more specific values and shapes as you go. Try this exercise with other still lifes and landscapes, attempting each time to see the shapes as opposed to all of the more specific details.

You can use the negative space created by these shapes to help draw this mug at a credible angle. Note where the lines from the handle meet up with the pen, and how the negative space between the handle and the mug is much more shrunken because of our vantage point.

DRAW
THIS
No 002

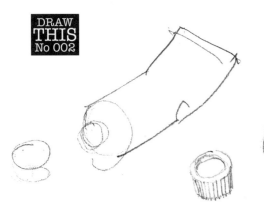

Step 1: Create a simple shape drawing of the tube. It's not a perfect rectangle, so try to get any bend in the shape at this stage.

Step 2: Be a little more specific with some of the folds, bends and angles. Just use line work at this point; it's better to have some good contours before you jump into adding value.

Step 3: Add in some value. The trick with painting a drawing is to not treat it like a colouring book. Adding in value at the drawing stage that you'll paint over later will help bridge the gap between line drawing and painting.

BUILDING VALUE

The transitional steps that you go through in order to combine drawing and painting can seem like an intimidating process. When you're working with pen or pencil, you only need to concern yourself with line and value, but adding in colour makes things a lot trickier. So let's go through the process of building up value, using a tube of gouache paint as an example.

You can study any colour tube you wish, but I'd recommend something on the darker side so that you can see the values a little more easily, i.e. blue over yellow.

Step 4: Apply a wash that is middle-of-the-road in terms of value. Make this a transparent layer, so that you are not covering the line work you've already laid down.

Step 5: After this transparent layer, you can add more opacity as you work on the lighter and darker values. With this tube, you'll mainly be using blues, plus whites for the highlights. As you push the values, use more pigment and less water so that the gouache appears thicker when applied.

Step 6: Mix up a deeper, darker version of the blue, for the darker values on the tube. You can mix this by adding a little red and a pinch of yellow. Add in the brightest highlights at the very end. Use a smaller brush for this.

Try this same exercise with a variety of paint tubes. When you're working on the colour, experiment with making the colours more vibrant or less saturated by adding in complementary colours – for example, using blue to mute an orange value, or yellow to mute violet.

Got a Perspective Issue?
Here's a Tissue

'Perspective' sounds very technical, but it's just a way of making things in your sketches look three-dimensional. There are two things you need to remember: objects appear to get smaller the further away they are, and straight parallel lines will appear to converge on a single point on the horizon. The basic principles are best illustrated by viewing a box in space: see how the top, bottom or sides appear to taper inwards, depending on the location of the vanishing point and horizon line.

It is often the case that objects will have different vanishing points. As you can see from the stack of books below, each angled book will have its own vanishing point.

Vanishing point (VP)

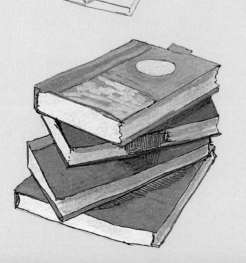

With these three overhead views of the same box, you can clearly see the object appearing to shrink in size as it gets further and further away. Note, too, the right and left top edges, and how they both travel back towards a single vanishing point on the horizon line. These diagonal lines are the strongest method you can use to show perspective.

These boxes illustrate two-point perspective – that is to say, there are lines extending towards two vanishing points along the horizon line, one on each side of the box. All of these boxes lie below eye level (that is, below the horizon line), which is why you can only see the top and two sides.

VP

VP

To create these boxes, start by drawing a vertical line indicating the edge closest to you, and then drag two lines from the top and two lines from the bottom point of that line to their respective vanishing points. Now add in the vertical lines for the left and right sides, and draw across the plane to each side's opposing vanishing point to map out the top of the box.

Now try this with more dynamic angles, where all angles are diagonal and the angles are more acute.

VP

VP

You can still use the vanishing points to determine the shape of the box, but the horizon line must remain perpendicular to the vertical lines of the box. You'll just have to tilt it a little to make it work.

Ellipses and Cylinders

Let's go over how to create cylinders and ellipses with some simple canister shapes. It's easy to see how a roll of tape, some fishing line and aerosol cans have the circular shape they need in order to function. But to place such rolls in space, we need to create a more elliptical shape.

Start out by creating a square and then divide it into four sections. Draw a circle within this shape. Then imagine pushing the square over backwards so that you view it in perspective. Your square is now a trapezoid and your circle becomes an ellipse. Your shape now exists within the constraints of the perspective space.

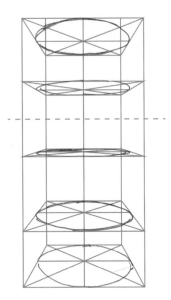

As seen in these rolls of tape, it's helpful to sketch in the whole of the ellipse as a rough guide. This helps you check the overall shape of visible (and invisible) sections.

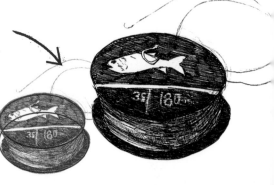

To help plot a realistic shape it's always good to draw in the whole of the ellipse, even if it won't be seen in the finished piece.

You can see how using the shape principle above can be used for different angles of ellipses. You don't need to measure this with a ruler – just do it by eye.

Cylinders can be viewed as joined-up ellipses. Try visualising the ellipses on an upright can or jar; they stay the same width, but their depth changes depending on their position in relation to your eye level.

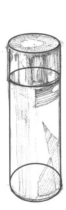

When cylinders are put into a receding perspective line, they get smaller.

Try working with more extreme angles by laying your aerosol cans on their side, rolling them away from you, and drawing them with the cap removed. Try to make each angle believable in its own space.

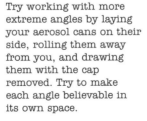

Even though the mannequin
has clearly segmented
pieces, you should begin
each drawing with a couple
of lines that go from head to
toe, and that summarise
the whole pose.

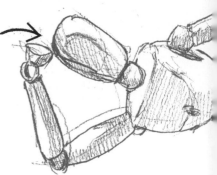

Thinking
along the
lines of a
perspective
exercise, this
means that the length of any
part of the mannequin will be
larger in front, and shrink
towards the back.

Try giving the figure a
more dynamic pose that
really illustrates the
depth and perspective
of space. This type of
positioning will mean
you have to convey the
foreshortening; you'll
have to show the length
and size of the figure as
it recedes into space.

DRAW THIS No 010 Figure it Out

Studying from a mannequin is a great
introduction to figure drawing. When you
don't have access to live models, take the
time to study poses from one of these.

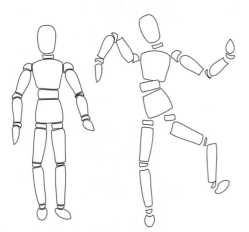

It's not quite like a stick figure, but you
want to think about building everything
from the inside and then moving
outwards, as opposed to tracing the
outside. Try working your mannequin
into some of these poses.

Try working in a
manner that is quick
at first, and then
slower later.

In figure drawing, you'll often
begin with quick 'gesture'
studies, which will typically
be poses that last less than
one minute. The purpose of
these studies is to get down
information quickly, and to
think about the body in its
full locomotion, as opposed to
a form made of separate parts.

Experiment with lighting
your mannequin from
different angles, bending
it into different poses or
positioning it in an
action sequence – and
study it for as long as
you like.

Drawing Cameras

What an incredible device a camera is. It's almost as if its details are an exoskeleton, and each shape has a function that's visible and understandable to the naked eye.

This digital camera needs lots of darks, but not so many that you lose sight of the object. Try drawing all of those highlighted areas out with finer lines first, then fill in the outer edges with brush strokes.

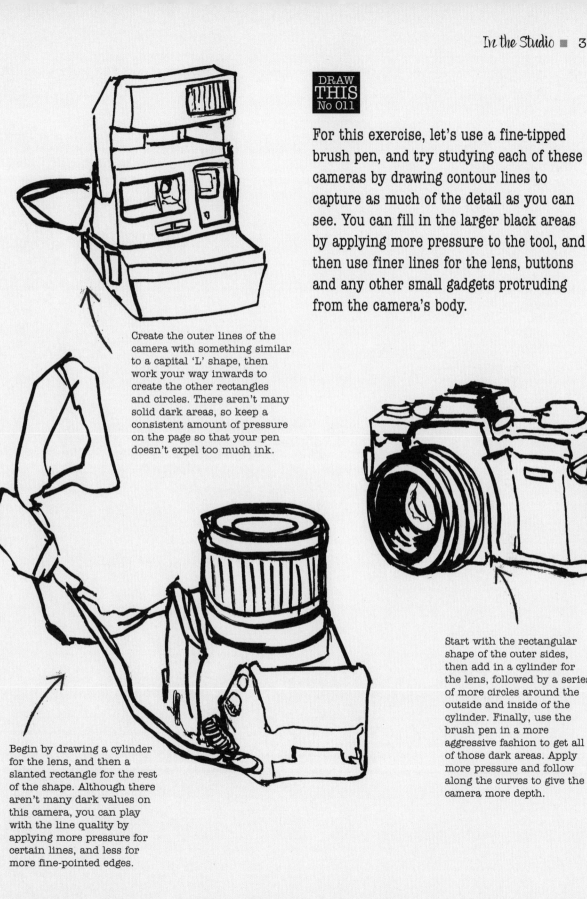

For this exercise, let's use a fine-tipped brush pen, and try studying each of these cameras by drawing contour lines to capture as much of the detail as you can see. You can fill in the larger black areas by applying more pressure to the tool, and then use finer lines for the lens, buttons and any other small gadgets protruding from the camera's body.

Create the outer lines of the camera with something similar to a capital 'L' shape, then work your way inwards to create the other rectangles and circles. There aren't many solid dark areas, so keep a consistent amount of pressure on the page so that your pen doesn't expel too much ink.

Start with the rectangular shape of the outer sides, then add in a cylinder for the lens, followed by a series of more circles around the outside and inside of the cylinder. Finally, use the brush pen in a more aggressive fashion to get all of those dark areas. Apply more pressure and follow along the curves to give the camera more depth.

Begin by drawing a cylinder for the lens, and then a slanted rectangle for the rest of the shape. Although there aren't many dark values on this camera, you can play with the line quality by applying more pressure for certain lines, and less for more fine-pointed edges.

These scissors are basically two triangle shapes meeting at a point, with a quick line splitting them in two. Next, draw a circle for where the screw sits. Veering from that point are the circle of the thumb hole, and then a bean-shaped oval for the finger hole.

Try to convey the gradual thickening of the handle by creating lines that curve upwards from the blade, and then add value to the right side to show the difference between the light and dark planes.

Begin by drawing 'L' or 'J' shapes for the ear buds. It's easy to get lost with all of the tangling cables, but keep a consistent thickness of line with the cords and they'll turn out great.

DRAW
THESE
Nos 012–024

13 Things from the Desk Drawer

Find objects both large and small, and break each one down into a simple shape. Some will be obvious, like the elongated, rectangular shape of a craft knife, and some will be more complex, like a pair of sunglasses. But you can begin each one with familiar shapes.

Start with an upside-down 'V' shape with a tiny circle at the point. Using parallel lines instead of cross-hatching for the shading helps to give the tool its smooth, metallic feel.

Where do you start with this complex object? First draw the cylinder, then align the rest of the elements with that. I made the tape transparent to simplify things a bit.

Your hands are the most important tool in the studio!
Drawing hands can be intimidating, but you can
master this skill by understanding
their basic structure.

DRAW THIS No 025

Try Your Hand at This

Step 1: Start with a square for the palm, then note the way the thumb and fingers fan outwards. You can draw this fanning line in lightly as a point of reference. Don't worry if the fingers look boxy and flat at first – you're just trying to get the basic shapes down at this stage.

Step 2: The middle finger is about the same size as the palm (A), so lightly draw this in first. The ring and index fingers are about a fingernail's distance down from the the tip of the middle finger (B). The pinky is about half the size of the middle finger (C). Lastly, the thumb (when lying close to the palm) reaches approximately the same point as the bottom of the middle finger (D).

Step 3: Add three-dimensionality by rendering the areas of light and dark. Don't worry about drawing the lines on the palm dark – they will emerge as you add the shadows.

DRAW THIS No 026

Draw Your Own Hand, Using a Mirror

Prop up a mirror on the opposite side of your writing hand and draw what you see. Obviously, you'll be moving a lot, so it's important to get down the basic shapes and lights and darks before working in all of the details.

There's no excuse for not practising drawing hands, as you have two life models readily available! Draw your own hand in a few different poses, and try to emphasise the bend and pressure in the muscles when the fingers are bent.

Handy Model

DRAW
THIS
No 027

See how the palm curls up when you fold in your fingers.

DRAW
THIS
No 028

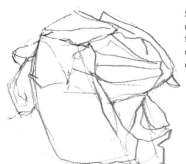

Step 2: Add a little more detail to the folds, but only focus on the really major ones – don't worry about every single one.

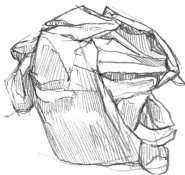

Step 1: Try to envision the crumpled-up newspaper as a white piece of paper with no wording or imagery. Draw that simple shape using contour lines.

Trash Talking: Crumples

While you may want to immediately dispose of crumpled paper or dirty oil rags, they actually make wonderful subjects for practising folds and drapery. Start with the basic lines that you see, and don't get caught up in all the details. Once you've established the major lines, add value to give definition, which will also provide clues as to the light source and hence the crumples and folds. But in the early stages, keep the values to a range of light, mid- and dark tones.

Step 3: Give the folds some value. Identify the light source and indicate which planes are clearly in light, and which are in shadow.

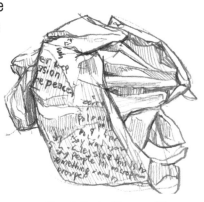

Step 4: Next add some of the type, but don't make these lines so dark that they bounce off your object. Whatever you add onto your crumpled-paper drawing should look as if it's affected by that same light source.

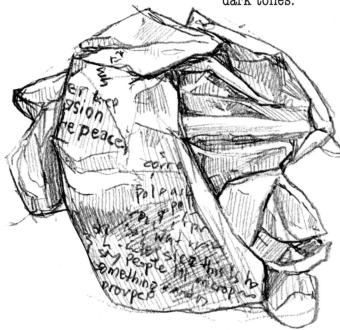

Step 5: Make the dark shadows darker and also darken some of the lighter areas a little if necessary. Consider the print on the newspaper: it needs to appear darker in the shadows and lighter in the light areas. If it is consistently dark, it will look out of place on the paper.

Step 1: Begin by drawing the paint rag as a very simple contour shape.

Trash Talking: Folds

Step 2: Begin to define some of the lines and add in some more specifics in the folds. Don't get carried away with the line work, as you can deal with some of that by adding value.

Step 3: Now add in some value. Concentrate on the most obvious values, which help to illustrate the folds and light source, and don't worry about the more subtle values. You can always add those later with paint.

Here you can see how the full range of tone is achieved by building up your drawing and allowing the values to work from broad to specific.

Step 4: Add a solid, thin layer of paint over the whole paper. Make sure it's muted, and add some slightly darker versions in the shadows.

Step 5: Now the fun part - splatter some paint into the messiest parts of the rag. Try to make your mess curve with the material, and also keep it consistent with the lighting. But be messy and have fun!

Drawing the human skull can be extremely challenging. There are a lot of ins and outs to deal with, so let's look at some of the basics, breaking it down into shapes we're already familiar with. You can approach portrait drawing with similar beginning stages, so understanding the human skull is a fantastic way to improve your skills.

FACIAL ANATOMY

DRAW THIS No 030

Step 1: First, put down the broad shape of the skull. It looks similar to a light bulb on top and a potted plant on the bottom, so start by sketching that. See what I mean?

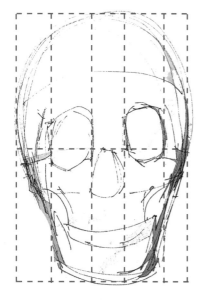

Step 2: Now add in the eye sockets, nose and mouth. There are some useful guidelines: the eyeballs are approximately halfway between the top and bottom of the skull; using the size of the eye socket, there's about one eye-socket distance between the eyes (where the nose will be); and the total width of the skull is five eyes wide.

Step 3: Add in some more contour lines. Try to show the depth of the sockets, and the foreshortening of the cheekbones using only line. Add in the teeth, but don't outline each tooth too heavily - just try to make clean contours.

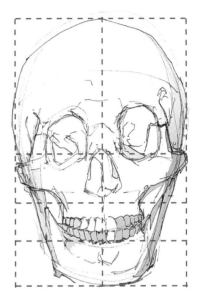

Step 4: Gradually build up the values. Note the areas that are in light, and those that are in shadow. The eye sockets are not necessarily the darkest part - in fact, areas near the teeth may be darker in value. Note also the angle of the teeth, and the way that the upper teeth catch more light than the bottom.

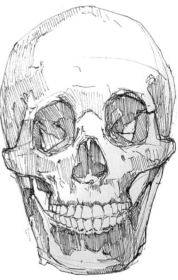

Step 5: Lastly, make some of the lines more solid, and some of the values darker. You can add as much detail as you want, but don't lose sight of the big picture. You may find sutures in the skull, but don't make those lines as dark as some of the deep shadows.

Try moving the lamp
around to play with
different angles of lighting
and see how the light affects
objects that are close up
versus those that are
further away.

The toy closest to the light
is lit fairly directly from
above, creating a shadow
that covers most of the
front and some of the back.

The shadow under the bike
is fairly small, giving a kind
of 'high noon' lighting effect
similar to what you'd see in
an old Western movie.

This bike, which is facing
away from the light, has
a more 'escapist' feel,
mostly because of the
longer shadow that is
pointing away from the
light source.

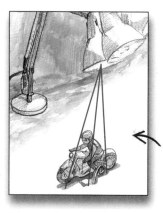

You can lightly draw a line
from the light source to the top
of the object, and then to the
ground, in order to find the size
of the shadow.

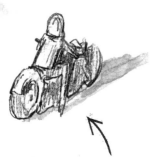

The bike furthest away is lit from our angle, and gives us the feeling of 'riding off into the sunset'.

DRAW THIS No 031 Hit the Lights

Adding proper shadows to an object not only helps you create a solid form, it also helps set the desired mood. Soft lighting can give a sense of peace and calmness, while stronger shadows can display excitement and action. However you set the mood, you need to be in control of the lighting. Let's use this motorcyclist toy as a way of learning about lighting techniques.

This bike has similar lighting to the 'escapist' toy, but the longer thin shadow gives the bike a more 'lone rider' appearance. The size and story seem more epic.

The bike furthest away from the light has the longest shadow, and the figure itself is mostly in shadow, except for certain parts of the helmet and edges of clothing. This makes the figure look quite sinister.

The length and size of the shadow help, too, as they make the motorcycle seem larger and more daunting than it really is.

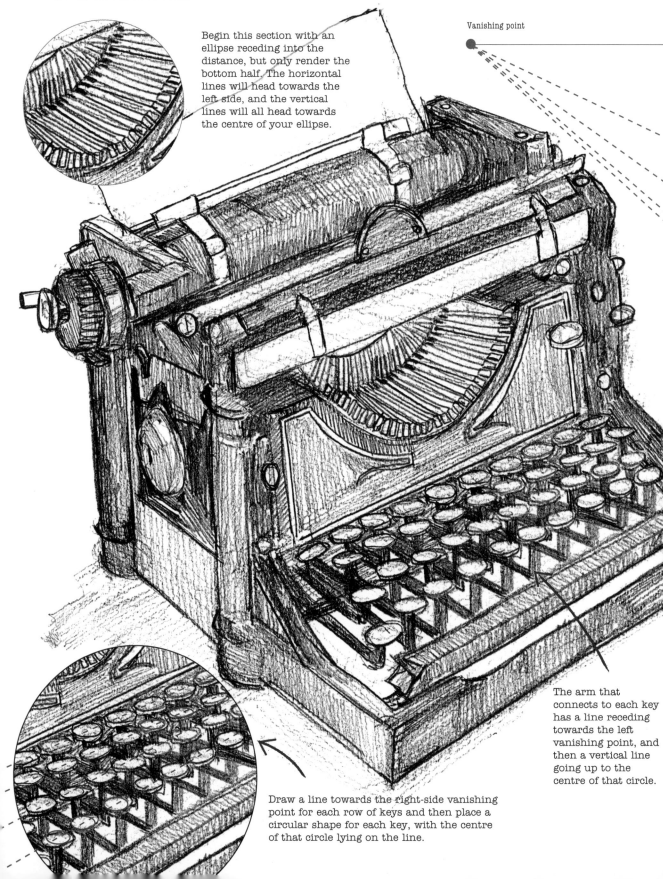

Begin this section with an ellipse receding into the distance, but only render the bottom half. The horizontal lines will head towards the left side, and the vertical lines will all head towards the centre of your ellipse.

Vanishing point

The arm that connects to each key has a line receding towards the left vanishing point, and then a vertical line going up to the centre of that circle.

Draw a line towards the right-side vanishing point for each row of keys and then place a circular shape for each key, with the centre of that circle lying on the line.

Vanishing point

Eyeline

Since there are plenty of details to work with, start with some of the major lines before getting into some of the minor ones. For example, just create an area for each edge of the keyboard before working on each key. Add value once you have enough horizontal and vertical lines to make a good foundation.

Starting at the bottom left, note how you can take the lines going along the bottom to the left and right towards their respective vanishing points. Following this approach, you can take each of the keys and any of the other horizontal parts to their vanishing point to give the typewriter its shape and depth.

Vanishing point

DRAW THESE Nos 032–033

Two-Point Typewriter

When you can see two sides of an object, as here, two-point perspective comes into play; each set of parallel lines will appear to recede towards its own vanishing point. This dynamic viewpoint of the typewriter helps to demonstrate the scale and proportion of the object.

By lying these three crumpled-up pieces of paper in a row, you can relay distance and space just by shrinking their scale towards this vanishing point.

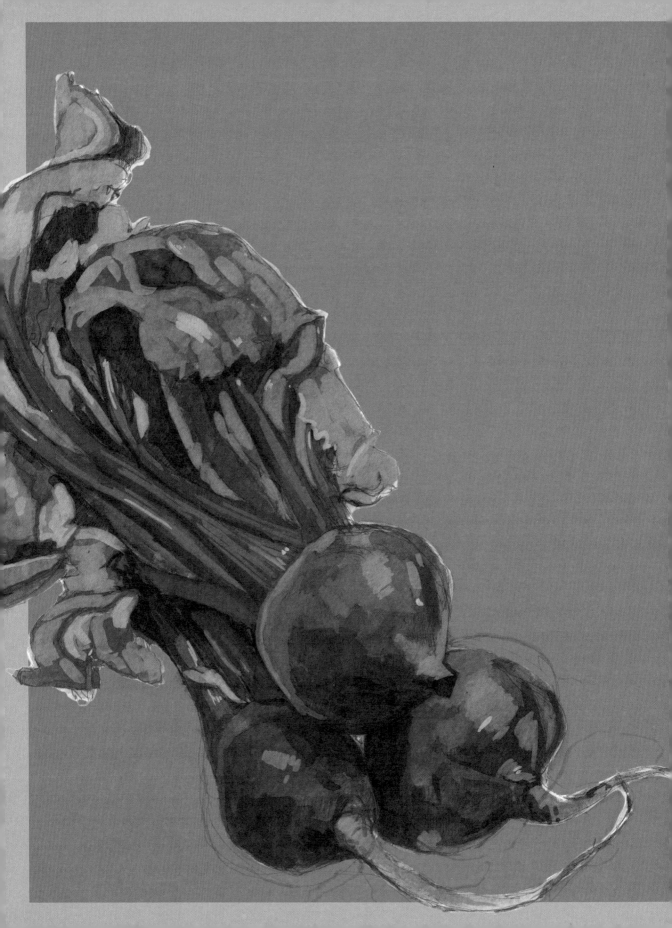

In the Kitchen

Your kitchen is filled with objects of all sorts, perfect for wonderful lessons in drawing the organic texture of food, the transparencies of glass and the mechanics of a toaster.

The wire around the edge is like a spring; keeping that in mind should help you if you get lost.

With this rubber spatula, focus on the simple shape of a rectangle within a rectangle, followed by the longer, slightly curving, line for the handle.

To make sketching this strainer simpler, start with the single circle flat on your table, with an almost rectangular shape jetting off the back. Then, lay ellipses on the left and right side of the flat circle, shrinking the ellipses' size as you add more around the edge.

Begin this meat thermometer by drawing an ellipse, and then take a line from the centre and drag it backwards.

Although this tin opener has a lot of elements, the initial shape is similar to a pair of scissors. Add in the circular shapes near the edge for the gears, and then some of the more hard-lined detail around that area.

Pay attention to the darkness between the gears, and how those darker lines help give the object weight and strength.

DRAW
THESE
Nos 034-043

10 Things from the kitchen

The best part about drawing objects from your kitchen is the variety of shapes you can come up with. Try to find a good mix of shapes, sizes, materials and degrees of complexity to work from. As always, start from simple shapes and then add value and detail.

This mashing tool starts with some fairly curvy lines, and to ensure that they don't appear flimsy you'll need to add areas of light and shadow. This will give the metallic parts more credibility. Pay close attention to how each line bends in and out as you add detail, and also notice the shadows they create.

This bread knife starts with a more rectangular shape.

When you get to the teeth, think of drawing small arches along the sharp edge.

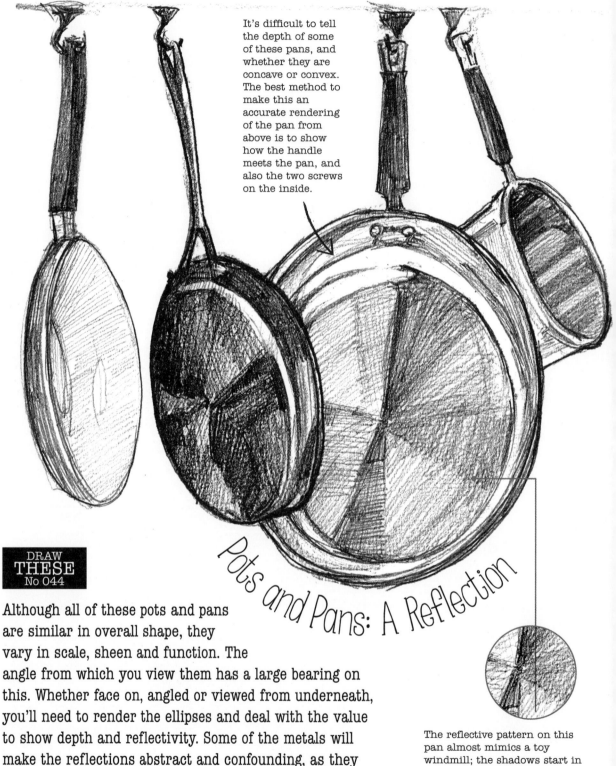

It's difficult to tell the depth of some of these pans, and whether they are concave or convex. The best method to make this an accurate rendering of the pan from above is to show how the handle meets the pan, and also the two screws on the inside.

Pots and Pans: A Reflection

DRAW THESE No 044

Although all of these pots and pans are similar in overall shape, they vary in scale, sheen and function. The angle from which you view them has a large bearing on this. Whether face on, angled or viewed from underneath, you'll need to render the ellipses and deal with the value to show depth and reflectivity. Some of the metals will make the reflections abstract and confounding, as they will reflect light, colour and other surrounding objects.

The reflective pattern on this pan almost mimics a toy windmill; the shadows start in the centre and almost instantly become bright at the edge.

The almost hour-glass shape of this strainer means that there are light sources on the bottom section that will reflect into the top, and vice versa. It's not quite a mirror image, but be on the lookout for those patterns.

Attempt some other shapes, such as a metallic sieve or spoon.

The bottom of this wok has some of the sheen of the other metallic pots, but there's a fuzziness to the chromatic features. Make the change between light and dark gradual, and use softer lines to help everything look smooth.

Glassware

The toughest aspect of drawing glassware is, without a doubt, the element of transparency. How do you illustrate something if you can see directly through it? What you need to remember is that even the most crystal-clear glass has characteristics which allow us to know that we are looking through it, such as distorted shapes, continued contour edges and blurry edges. The key is to focus on simple shapes first.

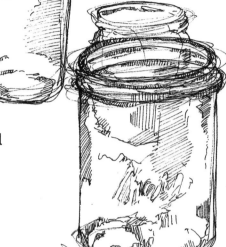

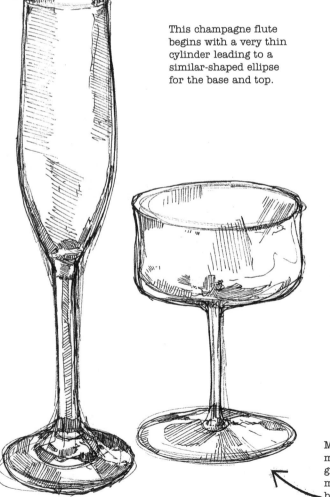

This champagne flute begins with a very thin cylinder leading to a similar-shaped ellipse for the base and top.

DRAW
THIS
No 045

CLEAR GLASS

Begin by using a very fine line to trace the shape of the object. Once you've done that, look for areas that are evidently concave or convex within the glass. Note where the glass dips down into the stem, and then the stem morphs into the base; these curving tones reveal the shape, density and flow of the glass.

Make sure you add a little more value to show the girth of the glass where it meets the stem. This helps to show its width.

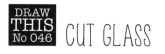 CUT GLASS

Don't get overwhelmed with detail: start off with shapes similar to the clear wine glasses, and then create the detail with values instead of straight contour lines.

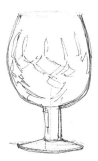 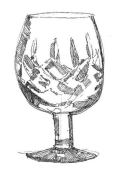 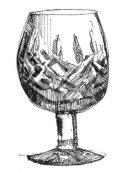

Step 1: Start with not only the shape of the glass, but also a quick study of the glass's design. Notice where the light is coming from, and how that affects the shadows. Rather than draw the diamond shapes out, only render the area in shadow.

Step 2: Next, add some more of those shadows on the side of the glass, and in some of the cut-glass design details.

Step 3: Everything will come together once you get those really dark values in. The depth of value helps to make this glass look clean, clear and shiny.

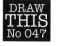

STACKED GLASSES

Drawing transparent objects stacked within other transparent objects presents particular challenges. It's important to notice all the lines, but not to lose sight of why the lines are there – namely to indicate the base of each individual glass and its angle in relation to the glass in which it sits.

Start off by drawing the manner in which each glass stacks inside the next. It's almost like drawing a cone inside a cone, except with a wider top.

The values get darker as you move down – you can see the darker bottoms of two other pint glasses inside the bottom one.

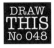

DRAW **THIS** No 048

Refrigerator

Drawing your refrigerator is a great way to discover the basics of one-point perspective.

You'll notice that the lines on each shelf and on the door will descend in space to a similar vanishing point. Though this point is not literally there, it operates as a mark for all of the objects in the fridge to recede towards.

DRAW **THIS** No 049

WHAT'S IN YOUR FRIDGE?

Grab a few items out of your fridge and try rendering them using one-point perspective as a means of giving the objects depth. Use food items in their containers, so that you can use the edges as a starting point.

Imagining single items as a box shape will help you find their vanishing point.

The butter dish uses the same principles as the egg box and cutting board.

VP

VP

With the egg box and cutting board, you can use both the left and right edges to guide you towards the vanishing point.

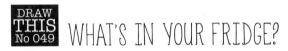

As you render your fridge, notice how each of the shelves is at a different eye level. You'll look down on some items, but view others face on.

IN THE FRIDGE

Taking a few objects from the refrigerator, we can study how transparency works. We have objects that exist inside a glass or plastic container, and we need to create a believable rendering of these objects. The trick is to render the outside container before dealing with the contents.

 PICKLE JAR

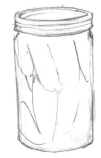

Step 1: Start with the solid outline of the jar. Add some detail to the lid, then add the shape of the pickles that are visible inside.

 WATER JUG

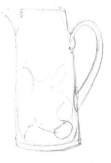 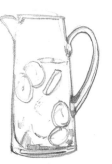

Step 1: Draw the shape of the jug first, which is almost a thick-necked bird with a tiny beak. Add in some of the harder edges, and lightly sketch some of the lemon and lime slices.

Step 2: Outline some of the glass edges more, and give the fruits a bit more shape. The contents inside should be a bit lighter than they would appear if they were outside the glass.

 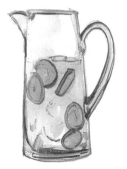

Step 3: Add some colour - a muted layer of a greyish blue, and then another slightly transparent layer on top of that to indicate the water line.

Step 4: Now add some muted colours to the fruit, and some muted bluish-grey values for the harder edges of the glass. Don't go too dark yet.

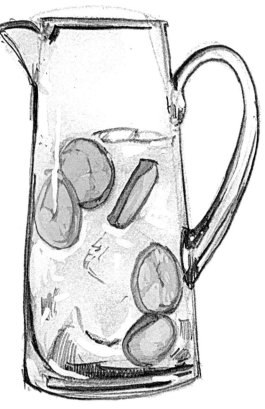

Step 5: Lastly, add some highlights and some darker lines to the glass. Putting highlights on the glass that overlap the fruit helps show that the fruit is behind the glass and in the container.

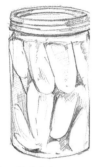

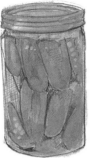

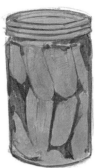

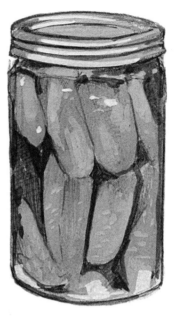

Step 2: Put down some darker shading in the negative spaces between the pickles, then add some harder lines on the lid.

Step 3: Paint on some initial colours – muted greens and some thicker grey values for the lid.

Step 4: Add some more values on the pickles, but don't make them too dark yet. They need to look as if they are inside the jar, so they will appear lighter than they would if you were painting them outside the jar.

Step 5: Push the values of the pickles and the lid by making some of the darks darker, and the greens more vibrant. As a finsihing touch, add some highlights to the glass.

 # PACKET OF SAUSAGES

DRAW THIS No 052

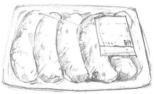

Step 1: Put down the rectangular shape of the packet and then some marks similar to parentheses for the sausages. Next, get a bit more in-depth with the sticker on the top of the plastic, and add some lines to indicate crinkling on the wrapping.

Step 2: Add some darker values to the sausages and underneath the sticker to help indicate that it's on top of the sausages.

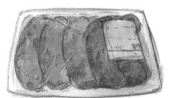

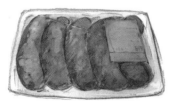

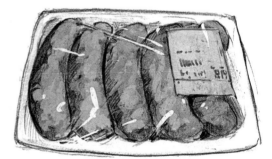

Step 3: Add in some colour. This reddish, muted colour is a good start for the sausages, and a more watered-down grey is good for the Styrofoam package.

Step 4: Add some thickness to the sausage colour and the sticker colour as well. Put in a slight shadow under the sausages so that they look as if they are sitting in the package.

Step 5: Lastly, push the values both lighter and darker, and reiterate those plastic cover lines in a white highlight. This really helps the sausages look as if they're under wraps.

Up and At 'Em

DRAW THIS No 053

Let's take this opportunity to study a few objects from two vantage points: at eye level and from directly above. For the overhead view of both the coffee mug and the bowl of cereal, we'll be drawing a complete circle, but these will need to be rendered as ellipses for the eye-level view.

Eye-level view

The trick with the eye-level view is to a) make the ellipse look credible and b) create the illusion of depth within the ellipse. This means adding a second ellipse inside the first for the coffee in the mug and the milk in the cereal bowl.

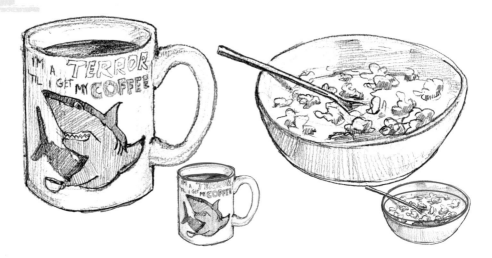

Overhead view

On the overhead view, you still need to add another circle for the levels of coffee and milk. However, you also need to deal with the angle of shadow, as well as with any shapes that help you understand the three-dimensional nature of the object.

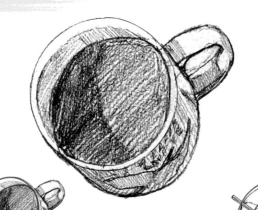

Adding a shadow on the left side of the coffee also helps you to see this as an object with some depth.

Curve of shadow

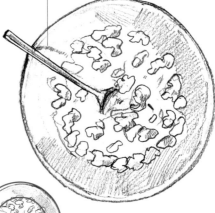

The relatively light shadow inside the bowl, shaped like a partially eclipsed moon, helps you to see the gentle curvature.

Doughnuts

DRAW THIS No 054

With this plate of doughnuts, we'll again be dealing with ellipses – but this time, they're imperfect in shape. Note how the doughnut holes are almost bursting inwards; that subtlety really helps to make them look doughy and delicious.

Eye-level view

The shadows cast by the doughnuts are much thinner in the eye-level view and the ellipses of the holes in the centre of the doughnuts are so narrow that they almost disappear.

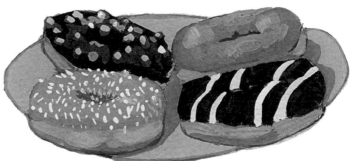

Overhead view

Viewed from above, the cast shadows are much more apparent and the holes in the centre are much rounder.

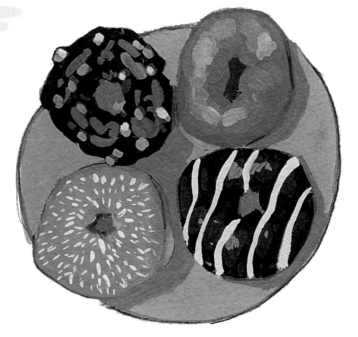

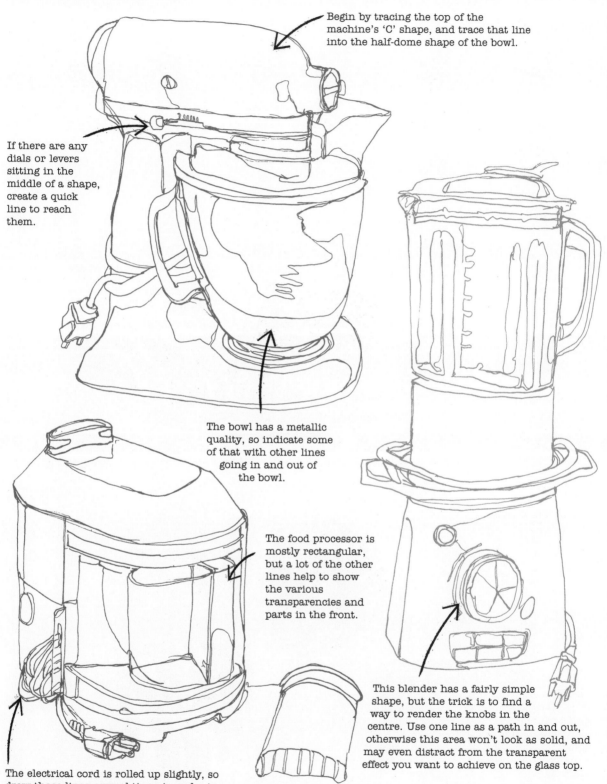

Begin by tracing the top of the machine's 'C' shape, and trace that line into the half-dome shape of the bowl.

If there are any dials or levers sitting in the middle of a shape, create a quick line to reach them.

The bowl has a metallic quality, so indicate some of that with other lines going in and out of the bowl.

The food processor is mostly rectangular, but a lot of the other lines help to show the various transparencies and parts in the front.

This blender has a fairly simple shape, but the trick is to find a way to render the knobs in the centre. Use one line as a path in and out, otherwise this area won't look as solid, and may even distract from the transparent effect you want to achieve on the glass top.

The electrical cord is rolled up slightly, so draw those lines several times in order to give the wire its wrapped-up effect.

Here, I began with the cord and then swapped into its boxy shape.

It's key to make the top slots appear as if they drop down into the toaster's body, so make sure those vertical lines help get that point across.

DRAW THESE
Nos 055-059

Kitchen Gadgets

The mechanical items in your kitchen make wonderful drawing subjects. They are usually aesthetically appealing, and they also have a lot of knobs and cords to make them interesting. For this exercise, let's try using contour lines as a way to capture all of the details. With contour drawing, you essentially focus on edges only, no shading. Also, try to refrain from lifting the pen from the paper.

The waffle iron will be as hard to draw as it is to clean! Each of the iron's interior squares needs to feel like a cube existing in three dimensions, so begin by drawing the two ellipses for the top and bottom of the iron, and then divide each of those circles into four parts. Within those four parts are a series of cubes that fill up the space. Just remember to take your time on this one – it'll be worth it when it's all done.

DRAW
THESE
Nos 060–061

Cutlery

A fork and a spoon seem simple enough, but it can be tricky
to capture their metallic nature, as well as any
aspect that is concave or convex relative to
the rest of the object.

A spoon has simple enough beginnings, with an oval and a few longer lines for the handle. Getting the depth and sheen are the hard parts.

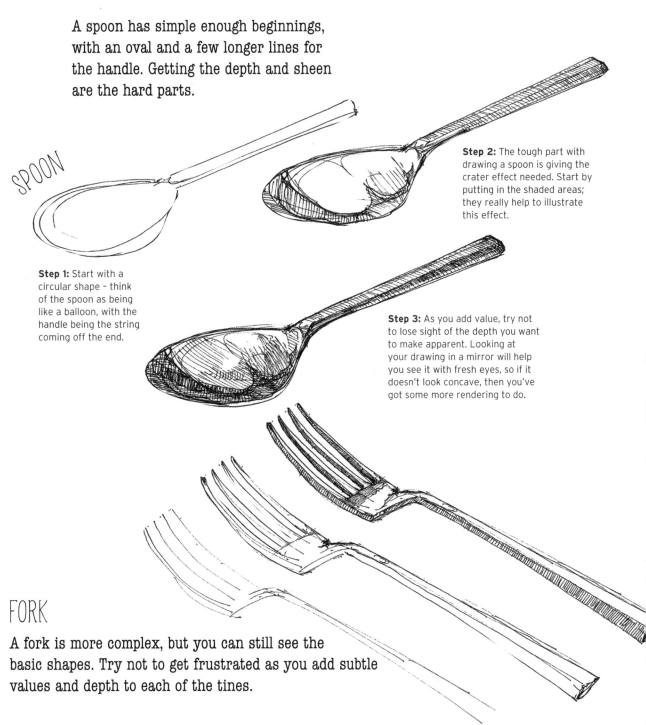

SPOON

Step 1: Start with a circular shape - think of the spoon as being like a balloon, with the handle being the string coming off the end.

Step 2: The tough part with drawing a spoon is giving the crater effect needed. Start by putting in the shaded areas; they really help to illustrate this effect.

Step 3: As you add value, try not to lose sight of the depth you want to make apparent. Looking at your drawing in a mirror will help you see it with fresh eyes, so if it doesn't look concave, then you've got some more rendering to do.

FORK

A fork is more complex, but you can still see the basic shapes. Try not to get frustrated as you add subtle values and depth to each of the tines.

Step 1: With a fork, you'll want to start with a shape almost like lightning bolt. The fork is shaped somewhat similarly to your own hand (see pages 34-35), so pay attention to how the tines have a direct connection to the handle.

Step 2: As you add more lines to make the fork look three-dimensional, notice how the tines taper to a sharp edge.

Step 3: Add value, making sure you show that the tines are not flat shapes, but rather boxlike and then flatten along their length.

When adding value to a drawing, it's important to get out of the 'colouring book' approach – you don't want to just create fields that you fill with colour. Make lines that have value; then, as you slowly build up layers of colour, those lines will show through, enhancing your drawing.

BEAUTIFUL BEETROOT

Step 1: Try to simplify the object as best you can. Here, there are a lot of colours, bends, curves and small details. Focus on the spherical shapes of the beetroot and how all the greens branch off. Draw a series of spheres, then draw lines branching outwards to indicate the leaves.

Step 2: Begin to create a sense of shape by sketching in some lights and darks to give form. Don't worry about the detail or how perfect each mark is; rather think of things a bit more abstractly, in terms of light and shadow.

Step 3: Using some gouache, begin by picking two or three basic colours. Think of these as theme values that hold the image together. Apply a transparent layer of each colour, making sure you add enough water so you can still see the line work.

Step 4: Build up layers of your basic colours to add depth. Notice that as the green gets darker, it needs a little more blue, and as the magenta gets darker, it needs a little more violet.

Step 5: Start to add detail. Use slightly thicker gouache and a smaller brush to add in some highlights, deeper shadows and subtle colour changes.

In a Stew
Over Pattern?

Cutting fruits and vegetables is a great way
to create two drawings out of one object. Each
of these has its own beauty on the outside,
but once cut open they feature a variety
of patterns.

The inside of this carrot
almost has a wagon
wheel pattern to it. So
that each slice looks
organic, think of these
lighter rings as having
a similar pattern to a
tree stump.

With each of these
patterns, it's a good
idea to work with
line and value
simultaneously so
that your mind
doesn't end up in
the stew as well.

ARTICHOKE

**DRAW
THIS
No 063**

Don't start the artichoke by
drawing its heart, but rather,
start off on the outside.
Once you have some kind of
silhouette, you can add in some
of the shapes of the heart – but
don't get too carried away or
confused with all the line work.

DRAW THIS No 064

PEAS IN A POD

These English peas are like a series of spheres in a long sleeping bag.

Step 1: Start by drawing out two lines that begin together, then taper away slightly and meet again.

Step 2: Lightly draw several circles inside the pod, and then enclose them within a shape that mimics your initial outline. Make sure the peas are peeking out.

Step 3: Add some value to show form. Darken the inside of the pod and add some value to the tops of the peas, where they touch the outer edge of the pod.

Step 4: Make some of the darks even darker, and add some more value to the peas to make them seem more three-dimensional.

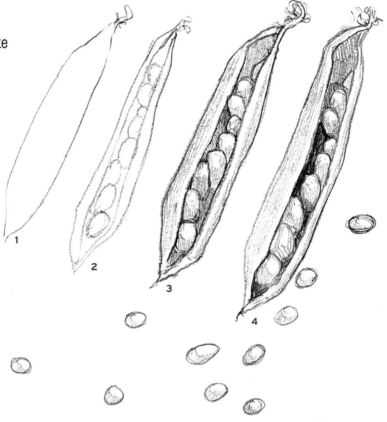

DRAW THIS No 065 ONION

The main challenge in drawing this interior is to identify the pattern, and then work within the constraints of the outer shape. Each segment needs to fit comfortably within the next, like a Russian doll.

Start with the vase-like white shape in the centre, and then follow that pattern outwards. Note how each white area has a certain thickness and is bordered by a vibrant colour.

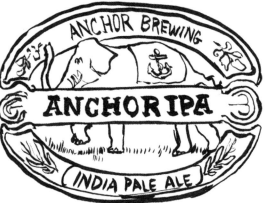

The Anchor IPA label has simple-looking letters. Since everything is nearly centred, I began by sketching out the oval for the banners, and then added in the Elephant afterwards. Note how 'Anchor IPA' fits within the width of the elephant.

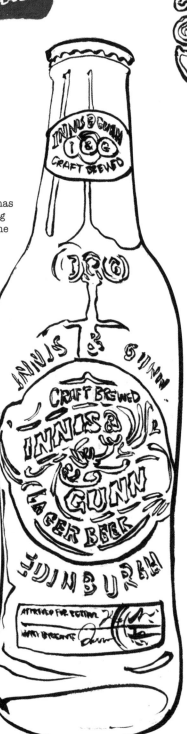

This Innis and Gunn bottle has one of the more fancy-looking labels, for sure. Take away the whimsical elements, and focus more on the shape the letters move in. If you create a circle in the centre of the label, the words almost wrap around that centre, but in a less curved arc. I like to draw in the first and last letter of each word first, so that I don't end up cramming in the letters as I reach the end of the line. Pay attention to the size of each letter, as well as the spacing. I'll draw each letter out lightly in a single line if need be, and then figure out the thickness after that.

This Ballast Point label has a boxier font, so I'm using broader strokes with a brush pen to get all of the bolder edges I need.

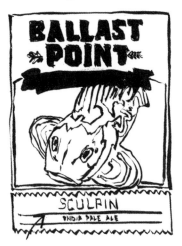

With the letters on the bottom, make sure they begin centred, and you can keep the font thin and straight.

Note the scale of the letter 'L' relative to the rest of the word.

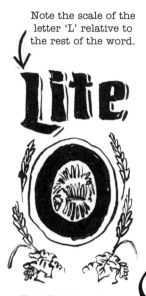

Pioneer has much fancier Old English letters. Use your brush pen to try to get these marks correct, and pay attention to the angle the letters are at.

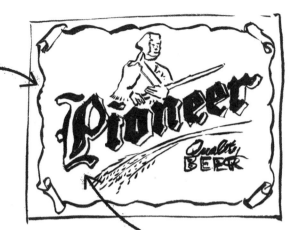

This 'Lite' beer has a boxy font, with some elegant curves on the edges. Using the brush pen for this can help you give a natural-looking finish to the letters.

The 'P' is definitely more grandiose, and the letters that follow are smaller and slightly less decorative in comparison. Note how each of the lines to create the letters arches inwards, creating a sharp angle at each point.

Make Mine a Beer

DRAW THESE
Nos 066-075

Creating letters by hand can be fun and expressive, but the difficulty lies in planning ahead, as well as in figuring out how to keep a consistent-looking typeface. Your lettering can look very loose, very bold or very decorative. Let's use these labels to study more.

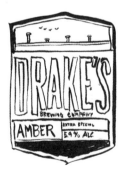

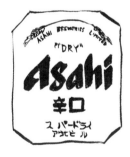

The letters are spaced in such a way that the first and last letter overlap the initial oval. Try drawing those letters out first.

This Eel River label begins with an oval, but the rest of the design is fairly asymmetrical. The name follows the upwards angle of the arched bridge, and the bridge itself is demonstrating some simple two-point perspective.

Now, unless you've consumed all of these beers as you sketched, go ahead and crack one open – you've earned it!

Colour Demystified

Mixing colours can be one of the most challenging aspects of art-making. Not only do you have to mix the right colours for your chosen subject (a green for leaves, for example), you also have to make each colour the correct value (a light or a dark green). To take some of the intimidation out of colour mixing, let's begin by mixing a few colours we already have in tubes. See pages 16–17 for more on mixing colours.

DRAW THIS No 076 MIXING PURPLE

Let's make a swatch using two of the three primary colours (red and blue) to create some of the secondary reddish-violet mixes we'll need for this pomegranate. (I've used cadmium red and phthalo blue gouache here.) By adding white to each of the mixes on the top row, we can create lighter values of each one. We won't be using any of the more blue-violet mixes, but it's good to know that you can now mix them.

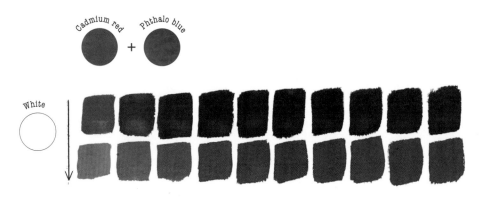

Cadmium red + Phthalo blue

White

DRAW THIS No 077

MIXING ORANGE AND GREEN

Try this same swatch exercise using each of the primary colours to make the two other secondaries – orange and green. If you create ten steps for each of these, you'll have the know-how to make 60 more colours once you add the white!

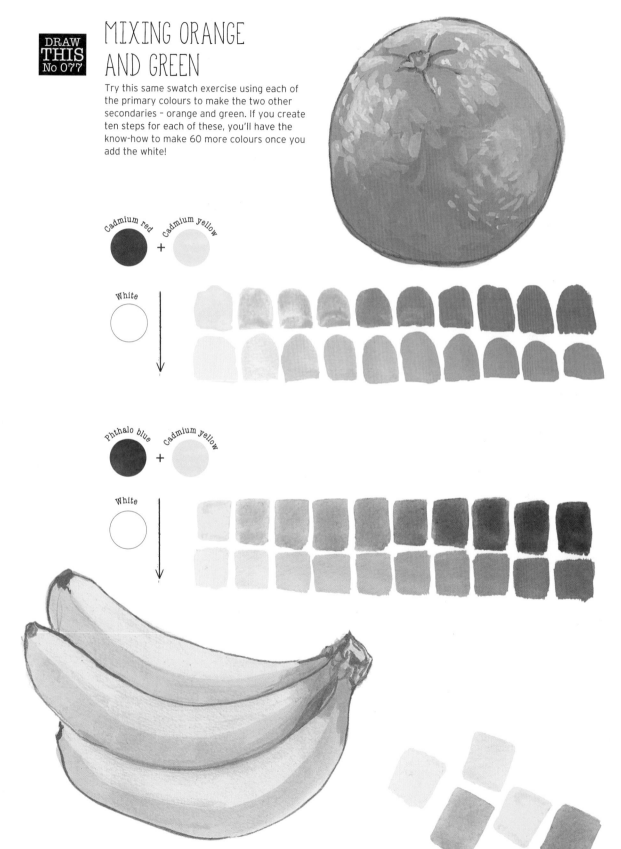

Cadmium red + Cadmium yellow

White

Phthalo blue + Cadmium yellow

White

Make sure that each of the whisk's long, metallic arches curves back into a believable place, and notice how many arches there are and where they land on the handle. The shading on the handle is similar to a cylinder, but make the transition between light and dark more abrupt.

Start by drawing the overall shape of the grater, and then turn your attention to the pattern of the holes. They are staggered from one row to the next, like bricks in a wall, so add each of those notches in that pattern, then make sure that the cavity lies flat against the metallic surface and then protrudes outwards.

The ladle has a wonderfully fluid shape, ending in a deep metal well. Make sure you contrast the dark areas with highlights to really capture the metallic nature of the utensil.

Describe the grain of this wooden spoon gingerly at first, and then a little more heavily later on, and pay attention to the weight of your line.

The potholder has a nice diamond pattern, but it also has a soft pillow texture. Make sure you describe the diamonds more by the value than by heavy line work.

The oven glove has almost a crocodile mouth shape, so you can start off with a shape like that. Like the potholder, it needs soft, pillowy lines in order to look believable.

DRAW THESE
Nos 078–083

Tools of the Kitchen

The kitchen is a great place to find tools with a variety of patterns and textures. From the signature toothy pattern of a grater to the softness of an oven glove, you'll find lots of challenging objects in your cupboards and drawers. The trick with a lot of these is to look for a pattern, and then work on the texture that pattern lives on.

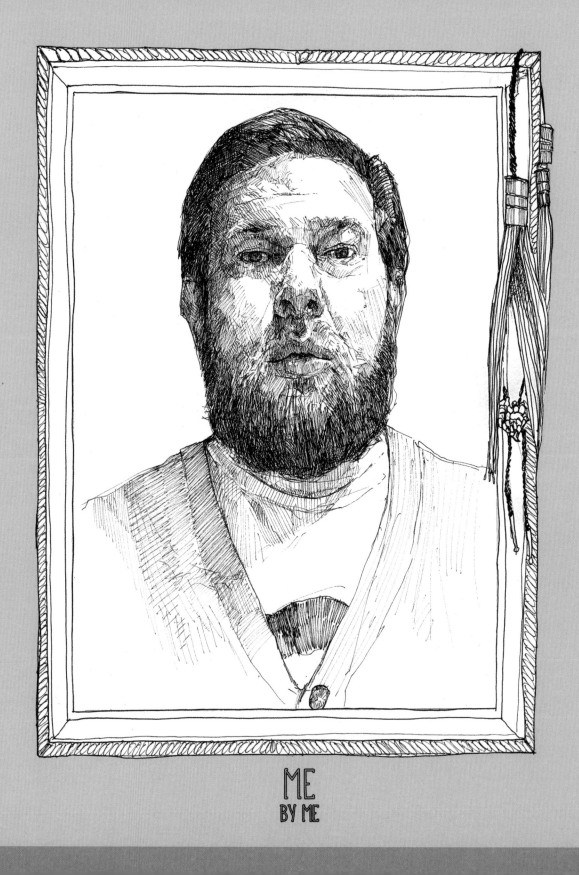

ME
BY ME

3

In the Bedroom

Dig through your room to work on sketches that will give you a chance to self-reflect – by studying clothes, shoes, patterns, hats, pets and your beautiful face.

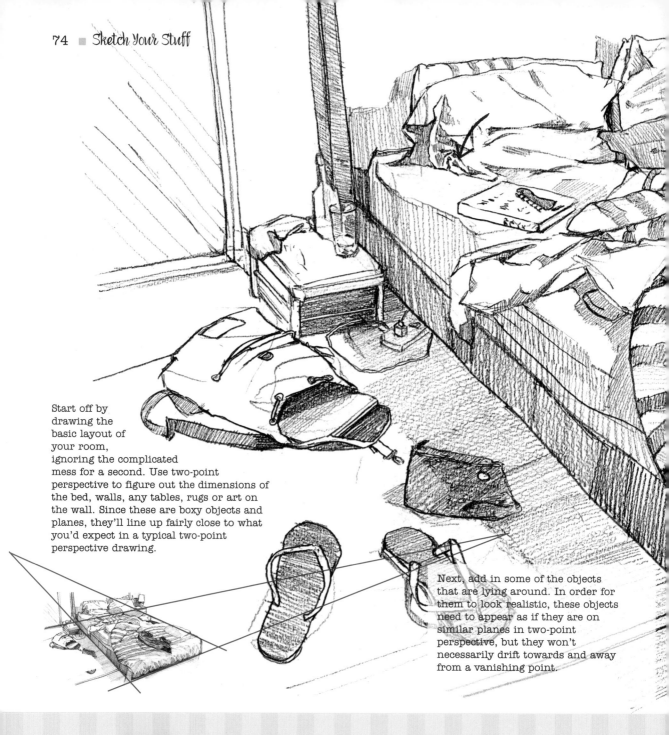

Start off by drawing the basic layout of your room, ignoring the complicated mess for a second. Use two-point perspective to figure out the dimensions of the bed, walls, any tables, rugs or art on the wall. Since these are boxy objects and planes, they'll line up fairly close to what you'd expect in a typical two-point perspective drawing.

Next, add in some of the objects that are lying around. In order for them to look realistic, these objects need to appear as if they are on similar planes in two-point perspective, but they won't necessarily drift towards and away from a vanishing point.

DRAW THIS No 084 — Messy Room

I'll assume that you do a fairly decent job of keeping your room tidy. But on the off-chance that the room is chaotic and messy, I'd like you to take advantage of it by using it as your subject for this exercise.

The stripes on the sheets begin drifting towards the right-hand vanishing point, but as they fold over they aren't so clearly affected.

The wobbly lines of the bed linen's stripes help to convey the organic look that you want.

With the shading on the sheets, breaking the lighting down into simple tones really helps. So think about separating everything out into either light or shadow, and make marks to differentiate between the two. The shadows should not be harsh at first, but dark enough to separate them from light.

When it comes to drawing the folds in the sheet, it's helpful to follow the outside edge and watch as it curls inwards. It's almost like making a sideways cursive 'L' – and once you get that shape down, you can start curving around the other edges.

These tile patterns are made up of quarter circles that snake up and down in a very orderly fashion. Try this pattern with colours of your own, and pick one that's lighter than the other.

This pattern is nearly symmetrical, but it has enough looseness and inconsistencies to give it a really organic feel.

Try to cover up nearly all of the space with colour on this one, and notice how much more pronounced the white space becomes due to its limited use.

DRAW THIS No 085

It's Doodle Time

Sometimes you don't feel like drawing an entire object and at that point it's best to just get some doodling out of your system. For this exercise, I was inspired by a lot of textile patterns and simple colours. I used markers, and rather than copy a pattern in its entirety, I've just inserted elements wherever I wanted to on the page. There is a certain beauty in pattern, and the rhythm of alternating shapes and colours can really enhance a picture. Whether you're adding patterned clothing to a portrait or filling a room with a retro wallpaper design, pattern can help strengthen the finished product.

This design has a tribal tattoo feel to it, and a lot of that has to do with mirroring your design. Whatever information you add to the left side, do the same to the right.

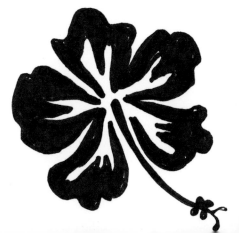

These sunglasses have a tortoiseshell frame, so the subtlety of that frame will need a different marking treatment. Note how the frames have darker values described by lines that do not crosshatch, making them look smoother.

These retro glasses have a wonderful lens shape, so make sure you get that shape down early on. To show that they are folded, pay attention to where the overlapping lines are, and which arm is lying on top of the other.

This pair of upside-down sunglasses helps you to look at the subject more abstractly. Think of the overall box that these sunglasses would fit in, and how that would be shaded. In order to render the smooth surface of the glasses and lenses, use lots of parallel lines as opposed to lines that cross over. My light source was on the left side, hence the powerful highlight on that lens.

This pair of glasses has a wooden frame, and even though the lenses are transparent, we want them to demonstrate their thickness by showing a few lines and subtle value changes.

DRAW
THESE
Nos 086-095

9 1/2

Cool Glasses

Glasses come in different shapes and sizes, but they all have to deal with a similar concept – they must cover your eyes. Since this is a universal truth, we can look at each of these glasses as beginning as an almost-circle, and then getting a little more extravagant from there.

To show the depth of these sunglasses, you'll need to give the illusion of the temple tips receding into the distance. This can be done by shading them a little more behind the lenses, and then making sure they don't have hard outlining.

Find noticeable folds in the shirt that you can make pop out.

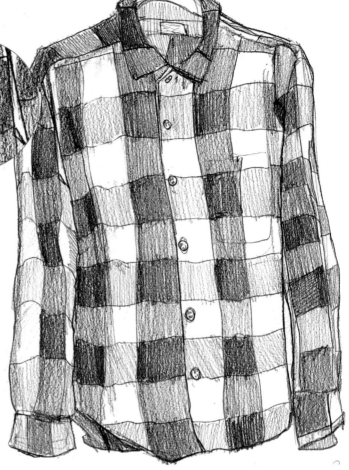

Fabric Pattern

Patterns are a lot easier to understand on a perfectly flat surface, but here we'll see how you can make clothing look much more dynamic by rendering patterns as they flow with the natural folds in the material. Working with a plaid shirt and a Hawaiian pattern, let's see how we can break these articles down.

Step 5: Lastly, add in some of the darker values, and find any noticeable folds in the shirt that you can make pop out.

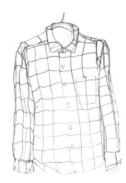

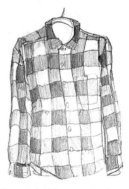

Step 1: With the plaid shirt, find a good, solid overall shape to start with - almost a tracing of the shirt shape.

Step 2: Now add in the collar shape, some of the buttons and some of the major visible folds. Ignore the plaid pattern for now - just try to get down the info that makes the shirt look credible.

Step 3: Start adding in the major line patterns that make up the plaid. It's important to notice how the lines curve as the fabric drapes and folds, so don't draw all the checks as rigid, straight-sided rectangles. Look for how the pattern breaks at the seam lines, too.

Step 4: Add in some basic values. This will not only help to show the way light hits the fabric, but it will also organise your line work and help make the shirt a little more clear.

Step 1: Start with a basic outline once again.

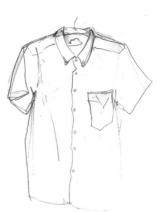

Step 2: Next, add in the major folds, collar and other contour work.

Step 3: Add some of the basic flower shapes, but don't go overboard. Leave yourself space to paint some of these without doing any preliminary line work – it'll make the pattern seem more natural.

Step 4: Add in some colour. Lay down a soft, muted layer for the background colour of the fabric, and then add some key colours for the flowers. Allow yourself to be loose with the flower colour, and remember to keep the colours a bit more muted at first.

Step 5: Lay down some more colours and, using a smaller brush, go in with slightly darker tones and outline some of the folds in the shirt. Now grab a mai tai and take the rest of the day off!

Look for common shapes in the dog's body to make things simple from the outset.

DRAW
THIS
No 098

Step 1: Try to really see the most basic shapes of the dog. I began with a sideways 'J' that is positioned inside a clamshell shape for the bed. The tips of the 'J' have a couple of sharp wave shapes coming off for the head and legs.

WHAT DO DOGS DREAM OF?

Sketching from life can present many challenges, one of them being that your subject may change over time, thereby putting a lot of importance on how long it takes you to render. A sleepy puppy will keep relatively still, but in order to create a drawing that feels solid, you need to grasp a lot of the key shapes early on.

Define darker lines with harder edges, and add some more quick marks for details in the fur and cushion.

Step 2: Introduce some of the shapes for the ears, nose and eyes. It's okay to create rounded-out shapes with loose lines to help you make the form feel more fluid. Flesh out the shapes for the legs, and make sure that the dog looks anatomically possible - you should try to have an understanding of where the legs and hips attach and fold inwards. Add some detail to the bed, too.

Add information to the bed and dog at the same time, so that the pup seems more grounded.

Step 3: Add in some of the values. Don't worry about all the subtle differences - just focus on the areas that are definitely dark or definitely light. Work on the pattern of the dog's fur, and then add some of the slightly darker areas around the head near the bed cushion. Add in some of the value to the bed, too.

Shade parts of the dog's fur and bed, but only work with a couple of values.

Step 4: Give more depth to the darker values, and add more detail and final touches. The darker patches of fur need some even darker value to help show the dog's anatomy, and the head needs some darker lines to help the eyes and nose pop out more. I also added some value to the cushion to help indicate the direction of the light source.

ME
BY ME

You Could Be a Part-Time Model

The best way to work on portraits – study yourself! Drawing a portrait can be one of the most difficult and intimidating tasks. Not only must it look accurate in terms of human anatomy, but it must also capture the person's likeness.

Step 1: Start by thinking less about all of the anatomy and work more on seeing some very basic shapes. Start off with the overall egg-like shape of the head, and add in the neck and shoulder lines. Keep these lines light; you'll get darker as you go.

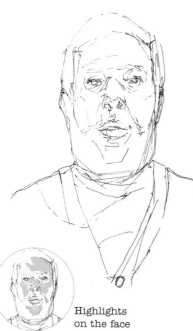

Highlights on the face

Shadows on the face

Step 2: Next, try to think of the 'planes' of the face: which areas are affected by light, and which areas are in shadow? Look for a pattern to help make this easier. With the light source coming from above, my forehead is in light, eyes slightly more in shadow, nose ridge in light, under nose in shadow, upper lip in shadow, lower lip in light, under-lower lip in shadow, chin in light and under jaw in shadow.

Step 3: Once you've established those shapes, add some value in to the areas that are in shadow, and try to outline some of the areas that are a little more prominent. Don't worry about getting too specific with the shadowing - just define areas that are definitely in light or definitely in shadow.

Step 4: Get a little more specific within the shaded areas. Make parts of the darker areas darker, and make some of the transitions on the lighter areas a bit softer on the cheeks, around the eyes, on the lips, etc.

With these large work boots, the shape to begin with is almost like a boomerang. Once you get that down, create a U-shaped curve at the top for the back of the boot, and then finish that wrap-around with another curve for the tongue.

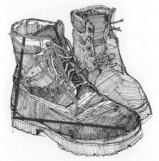

Note how there is almost a triangular shape that begins near where your ankle would be, and then proceeds forwards to the laces. It's a pattern to look out for in many shoes.

Draw the foot-shaped sole, then add a wishbone-like shape above that. Note how this shape curves out and then folds back in, and pay attention to the shadow it creates, too. This helps to describe the depth.

With these lighter high heels, start by drawing the angle that goes from the top of the heel to the toe, then add the straight line for the heel itself. Do that same shape for the left shoe on its side. If you get these angles right, the rest will look much more believable.

10 Shoes That Fit

DRAW THESE
Nos 100–109

It's amazing what a variety of shoes there are out there. Each design must begin with the same foot shape – but beyond that, the sky is the limit. So when drawing each of these, keep that same formula in mind: draw the shape of the foot first, then add the details.

Try to capture the length and slightly floppy nature of these Wellington boots by using a less cross-hatched style of shading. This will also help the boots look a bit more matte, and rubbery.

Travelling is one of the best times to have a sketchbook and pen handy. You can draw at your destination or during the journey. One of my favourite places to sketch is at an airport. The people-watching is always amazing, and everyone is so distracted that they'll keep still and not even notice you're sketching them! But it's also fun to just capture the atmosphere, be it a beautiful landscape or a busy terminal. In order to capture a scene such as this, it's very helpful to get quicker at sketching.

DRAW THESE
Nos 110–113

Adios Amigos

I like to think of using contour lines at times like this – where you don't necessarily worry about all of the shading, and you don't pick your pen up. You're describing everything with line, and so you have more of an opportunity to capture a subject's unique qualities.

Practise on some of the bags you may pack on your trip, and think about how you'll capture the qualities of each bag by using line alone. With this suitcase, it's important to get the labels on, but it's also helpful to notice how the corners and the straps help to make the suitcase look sturdy and more vintage.

With this backpack, try to see how
the boxy nature of one of the
pockets makes the pack seem full,
while the lines towards the top
tend to fold over and flatten,
making it seem empty.

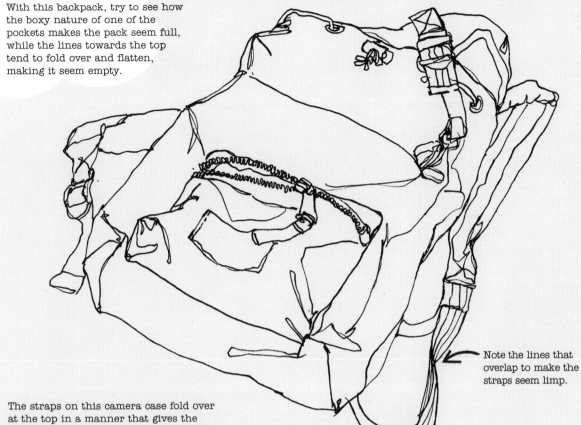

Note the lines that
overlap to make the
straps seem limp.

The straps on this camera case fold over
at the top in a manner that gives the
bag a softer feel, as opposed to the hard
edge of the suitcase. There's also a
certain puffiness to the edges of the
pocket to make it look a little full.

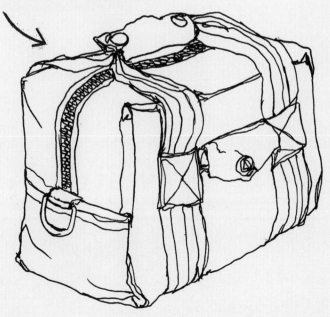

This close-up of a zip helps
show the rhythm and pattern
of each metal piece. It may
take painstakingly long to
draw each staple-shaped part,
but it looks great if you take
your time and handle each
one with care.

With this straw hat, use cross-hatching for the shadows, and beware of making any long, dark lines. All of the marks in this hat almost come to a sudden stop. As always, it's these small differences that count.

Put a Lid on it

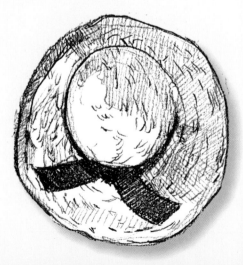

DRAW THESE Nos 114–123

10

Drawing hats can seem like a really easy task, but the trick is all in the subtleties – making the material look accurate, creating depth, depicting folds and showing accurate scale.

It's the concave centre in this trilby hat that makes it look credible. Notice the pattern of light–dark–light–dark, and the triangular shape the hat takes in order to create this divot. Creating a good light source helps, too.

Here, you're dealing with a similar divot to the trilby, and then adding in a cow-print pattern. Note how the subtle curve in the hat's brim is described by manipulating that oval ever so slightly. Have fun with the pattern – yee haw!

With this gardening hat, start with two simple circular shapes, and then give it some form using value. In order to give this hat a softer feel, make quick marks that don't hatch over one another. Think of the top of this hat as a sphere to give yourself an idea of how to shade it.

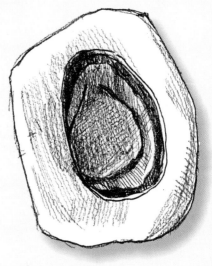

I made sure some money was popping out to make things interesting, and I added in some quick stipple marks for the stitching.

Start with a couple of diamond shapes for each side of the wallet. Add in the centre connection, and then some of the pockets.

Out of Pocket

Whenever you think you've run out of items to sketch, think again and check your pockets. Wallets, keys, lighters, coins – whatever it might be, you can find a way to make a mundane object seem interesting by the way you render it. I've chosen to work with a brush pen here because I can use quick, broad strokes to define each of these objects simplistically.

Begin the matchbook with a couple of squares, and then add in all of the shapes for the matches; they should look as though they are all stacked on top of one another.

The receipt starts out with an upside-down check-mark for the outer right edge, and then a similar line for the other side.

Once you add the edge of the matchbook folding over the top of the matches, they'll look a little more three-dimensional.

Add in some lines to show folds in the paper, and then place the barcode and other information near the end.

Note the circles and ellipses at the top – there are three different types. One is a hole, one is a wheel with grooves on its side, and the last is at an angle.

The lighter is not a perfect cylinder, but it's close to one. Start off with that slightly curved bottom and then bring a rectangle shape up towards the top.

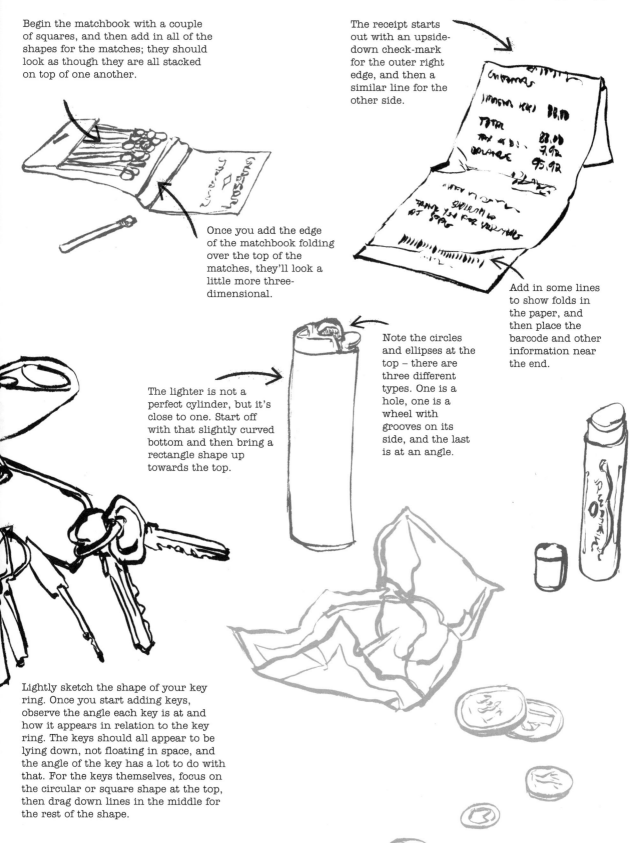

Lightly sketch the shape of your key ring. Once you start adding keys, observe the angle each key is at and how it appears in relation to the key ring. The keys should all appear to be lying down, not floating in space, and the angle of the key has a lot to do with that. For the keys themselves, focus on the circular or square shape at the top, then drag down lines in the middle for the rest of the shape.

In the Bathroom

Your bathroom is filled with objects of exciting and varied textures, and in this chapter we'll explore how to make them appear smooth, shiny, matte and wet.

By working larger you can
create a very detailed sketch,
capturing the subtle changes in
value in the tube's many kinks
and folds, and the bright
highlights on the glistening
toothpaste as it oozes out.

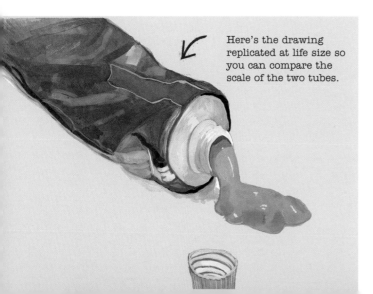

Here's the drawing
replicated at life size so
you can compare the
scale of the two tubes.

You can also study the stages of a shape as it changes, or in the case of the toothpaste, how it rolls up and scrunches.

DRAW THIS No 133

Playing with Scale

Taking a small object and rendering it at a much larger scale can be very liberating: it feels great to work with your full arm, as opposed to just your wrist – or even just to use a larger brush for a change. By working larger, you can also capture every small detail, crevice, shadow and highlight.

COMBINING SHAPES

The more you stare at an object, the more complex and intimidating it can seem, but no matter what you're sketching, you can break everything down into simple shapes. So when you're studying an object like this rubber duck, summarise it into a couple of shapes and only then start to to think about the colours, texture and shading.

Now all you need are Bert and Ernie for this bath session to be a success!

DRAW
THIS
No 134

Step 1: Draw two comma shapes: one for the body and tail, one for the head and beak. You can begin with two circles to make things even easier.

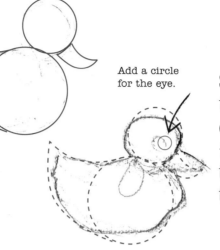

Add a circle for the eye.

Step 2: Morph the commas together slightly. There's almost an S-shaped curve from specifics such as the edge of the beak and the location of the eyes.

Step 3: Add in some more lines to indicate areas of light and dark. The marks you make should have an element of softness to them, so that the edges don't look unnaturally hard.

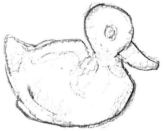

Don't add too much shading at this point – try to accomplish this with paint.

Step 4: Lay down a muted yellow - not as bright as the final yellow will be, as you want to work your way up to the bright colours. Add in some orange for the beak, too.

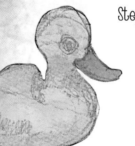

Step 5: Now add in brighter yellow (note how that first yellow has become a good shadow colour). Also add in some brighter orange on the tail and at the base of the beak, and some highlights to give the duck that glossy, plastic feel.

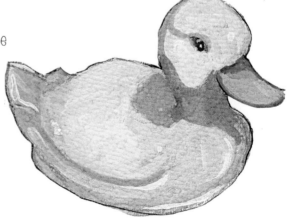

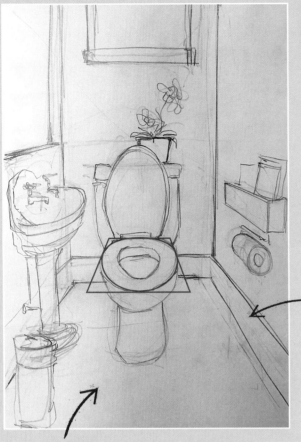

DRAW
THIS
No 135

The Smallest Room

Although it's the last place you'd think to practise sketching anything, your bathroom may be the best place to study two-point perspective. And it's probably a safe bet that it's a tiny enough space to get all of the info you need without scanning around too much.

To start, study the simple things: follow the lines along the wall, the floor, any lines from the sink or mirror, to a single vanishing point. Once you've done this, you can frame out the walls, and render a sense of space.

To add in the toilet bowl, or anything else elliptical, try creating a square that would go around each shape and put that square in perspective with the rest of the objects. For the toilet bowl, you'd add this square at the rim of the bowl, and then fill in the ellipse for the rest of the shape. The toilet bowl is not a perfect ellipse, so be aware of any slightly curved or flat areas that help define its specific shape.

After you've added in the toilet and some of the other info, add in some shading to give a sense of where the light is coming from.

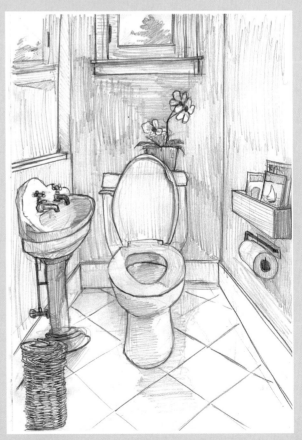

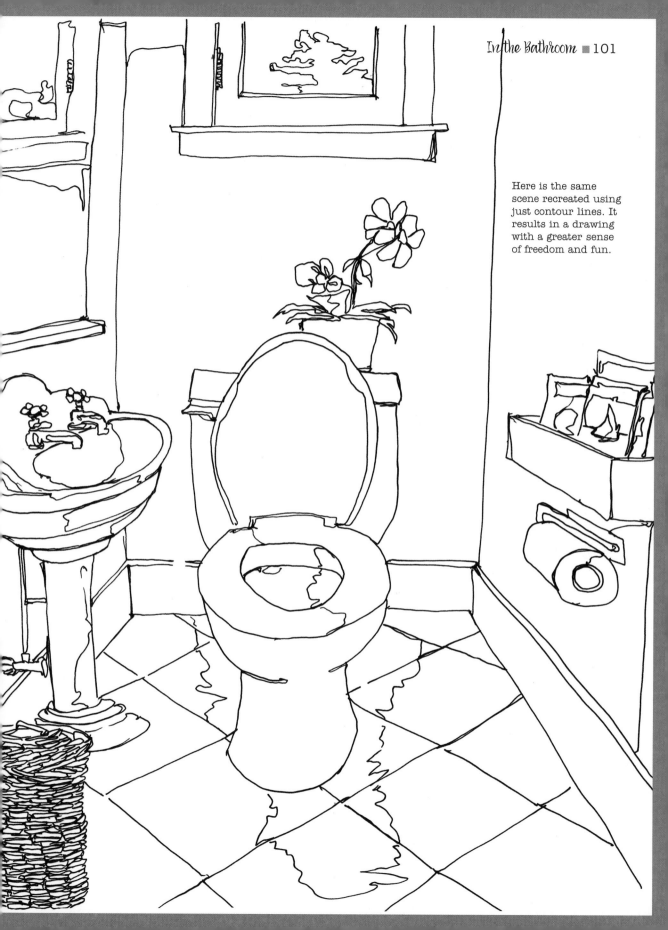

Here is the same scene recreated using just contour lines. It results in a drawing with a greater sense of freedom and fun.

The nailbrush needs a combination of hard, closely hatched lines for the solid wooden handle, and softer, quick lines for the bristles. The bristles should almost look as if they are exploding out of the handle; make sure you leave some vertical gaps between and within the sets of bristles so that they don't look like a solid mass.

Make very quick, small marks on the top and sides of the sponge to show the flaws, and make sure the outer edges also have some imperfections. They should look like tiny craters.

DRAW THESE Nos 136–142

Textures and Folds

There are plenty of textures to study in your bathroom, and appropriate line handling can make all the difference. A variety of hatching lends itself to rough surfaces, and quick marks in the same direction can give a sense of smoothness and fluidity. Vary the direction of your lines, too, to illustrate the different planes of your subject.

To capture the rigid, dry surface of the pumice, use hard, straight lines to convey the form and dark scribbles for the crevices. Be solid and absolute with your marks.

For a loofah, start with a cylindrical shape, and render the values with quick, slightly curled marks of irregular length. The lines should all curve in, towards the ends, to illustrate the soft, curvy nature of the material. Darken the stronger lines as you go, so as not to get lost.

A mesh loofah can be a confounding object to study. It's not only chaotic, but also transparent. Start off by rendering it as if it is a cloud, and then overlap certain lines almost as if you are drawing a Venn diagram. Don't try to draw all of the mesh – you'll go insane. Just slowly render the curves, and the areas of light and dark. Then use criss-cross marks for the mesh itself.

Wobbly lines around the edges of the towels in this stack tell us that they are made of a soft material; try not to make them too heavy, although they do need to be quite dense for the shadows between the individual towels. Vary the direction of your lines to show how the fabric folds and drapes.

Vary the density of your cross-hatching to create darker areas where there are several overlapping layers of mesh.

When fabric is wet, it tends to sag and therefore won't feel or look as fluffy. So with this flannel you can use harder lines and shadows than in the stack of towels, which in turn will help show its moistness.

For the water coming out of a shower head, think about the speed and pace of the water flow. Your lines should embody that motion; they should be quick and straight, and should fan outwards from the holes in the shower head. The end result should look similar to rays of sunshine.

DRAW
THESE
Nos 143-145

Clean Lines for Clear Water

Drawing water can be a very intimidating task. A good rendering deals with transparency and reflectiveness, as well as contortions in shape and value. For this exercise, begin by focusing more on the line work than anything; in doing so, you will see the patterns and shapes that will help make your rendering look accurate.

The flow of water down the drain requires a very different treatment. Almost like the lines of a hurricane, these lines will start from an outer edge and then veer inside towards the centre; this creates an elliptical shape similar to that of a pinwheel. Make sure you outline some of the more prominent parts of the metal drain, to show that it is not liquid – those harder edges will help the viewer to tell the difference.

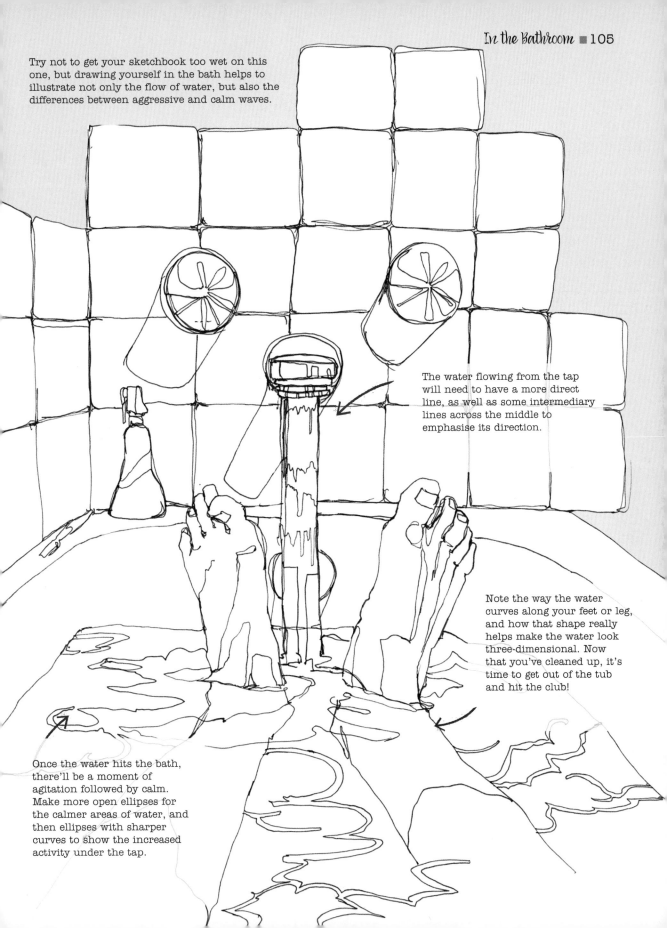

Try not to get your sketchbook too wet on this one, but drawing yourself in the bath helps to illustrate not only the flow of water, but also the differences between aggressive and calm waves.

The water flowing from the tap will need to have a more direct line, as well as some intermediary lines across the middle to emphasise its direction.

Note the way the water curves along your feet or leg, and how that shape really helps make the water look three-dimensional. Now that you've cleaned up, it's time to get out of the tub and hit the club!

Once the water hits the bath, there'll be a moment of agitation followed by calm. Make more open ellipses for the calmer areas of water, and then ellipses with sharper curves to show the increased activity under the tap.

With this pot of blusher, try to accurately illustrate the plastic cap on top and the slightly concave nature of the insides by creating some parallel lines that glaze carefully over the top.

Note how the shape of the nail polish bottle begins square and ultimately becomes cylindrical. You can only describe this with a few edges, though, because the bottle still needs to appear transparent.

Draw the overall shape of the scissors first, and then add a slight thickening of the lines around the handle to convey depth. Remember: the crisper the line, the better.

9

DRAW **THESE** Nos 146–154

Make-up Items

There are plenty of great shapes to study in a make-up bag. The key with each of these is to notice the differences in transparency, sheen and texture.

The eyeliner is created largely with dark tones, so the way you'd capture its roundness depends solely on the curved lines that wrap around the body.

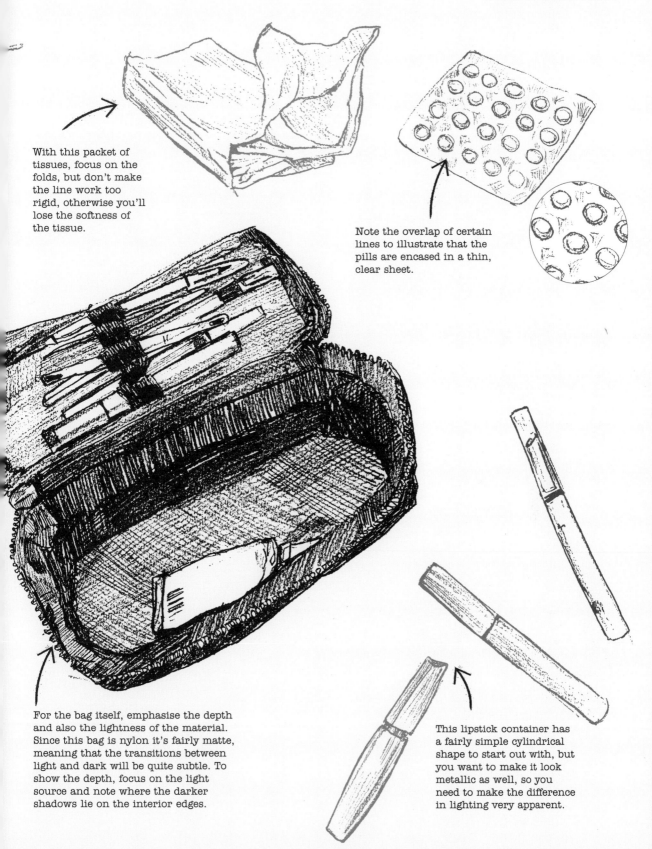

With this packet of tissues, focus on the folds, but don't make the line work too rigid, otherwise you'll lose the softness of the tissue.

Note the overlap of certain lines to illustrate that the pills are encased in a thin, clear sheet.

For the bag itself, emphasise the depth and also the lightness of the material. Since this bag is nylon it's fairly matte, meaning that the transitions between light and dark will be quite subtle. To show the depth, focus on the light source and note where the darker shadows lie on the interior edges.

This lipstick container has a fairly simple cylindrical shape to start out with, but you want to make it look metallic as well, so you need to make the difference in lighting very apparent.

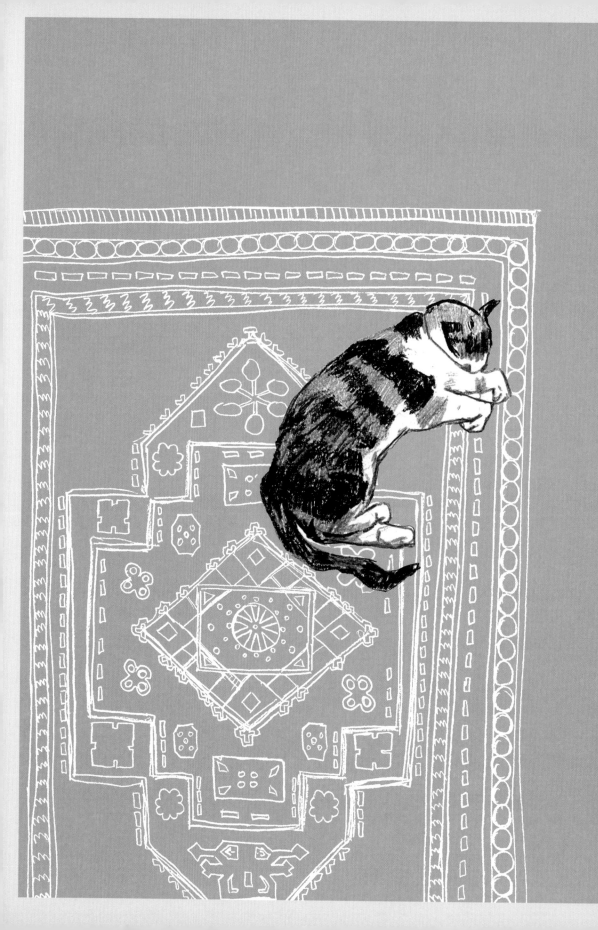

In the Lounge

With a lot more items, pets and people, your communal living space provides many subjects that may seem complex and intimidating, but we'll break them down into simpler forms.

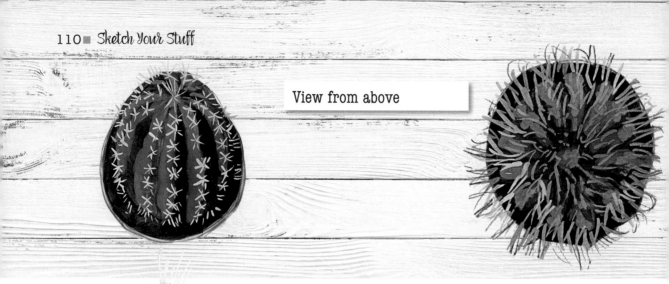

View from above

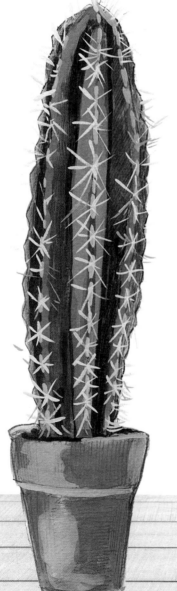

DRAW
THESE
Nos 155-163

Cacti

Each of these varieties of cacti and succulents has a fairly straightforward simple shape, and then a pattern within that shape that is nearly symmetrical – but not so perfect as to disrupt the organic look that the rendering demands.

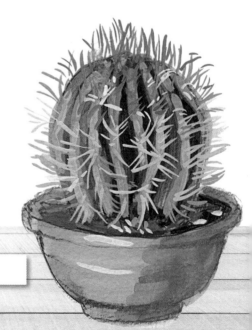

View from the side

The symmetry and patterns are almost easier to see from straight above. You can see how each cactus has almost a spirograph quality to it, as if each shape is hugging the shape next to it.

From above this succulent looks almost rose-like. Notice how each shape envelops the piece in front and behind it. Start with that 'U' shape in the centre, and then build around it. The colours are more of a bluish purple towards the base, and then add a little more red and white as you get to the tips.

These three cacti are tall and skinny, but it's hard to describe that from above. Think about the ellipse shape that each of these cacti makes, and add that in before anything else. Once you add in the off-centre top, and some of the shading, you'll be able to help show the depth.

With this tentacle-like plant, start by drawing lines that all branch out from the centre, making the ones closer to the base a little longer and flatter, and then have them gradually curve upwards.

Leave the thorns for the end, but don't just place them haphazardly. Note how they branch out of a central point, and how that point has a pattern to it as well.

Spin Class

Hopefully you or someone you know owns a record player – it's not only the best way to listen to music, it's also a great object to draw. For starters, it's very simple to break it down into shapes you're familiar with, and then you've also got elements like the glossiness of the vinyl and the transparency of the lid.

Add in some value, but make sure that you give the album itself the darkest areas. The difference between those lights and darks will give the illusion of glossiness.

Vanishing point

Vanishing point

It's best to start out with a block created using some two-point perspective (see page 42–43). You'll notice that there are a few other lines and marks that you can line up using those vanishing points. You can also create squares within this block to help you shape out the ellipses you'll need for the vinyl, as well as any of the knobs.

DRAW THIS No 165

Cassette

If you don't personally own a tape cassette, ask the most gutter-punk friend you have. Start with the rectangular shape and then add the two circles near the centre.

Even though this tape is transparent, its edges are still affected by light – so note how those areas darken depending on the light source.

Add a lot of titanium white to your pigment to ensure that these tones have the necessary vibrancy to bounce off the object.

DRAW THIS No 166 CD

With the CD, start by laying down some grey tone with gouache and then, to get those laser-esque lines, load up your brush with a vibrant tone and make an opaque straight line. Some of these lines have multiple tones, but remember to make them bright. Ok – now you can throw on that Prince album and dance like nobody's looking!

Show some shading coming from right under the kitty to show the weight of the cat on this surface.

You want this sofa to look nice and cosy, so make sure that, as you draw the cushions, you rely on soft shading methods as opposed to heavy line work.

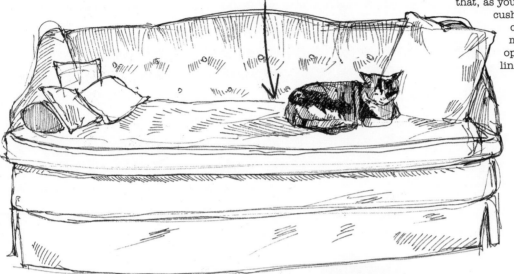

DRAW THESE Nos 167–171

Have a Seat

Some of the chairs you have in your lounge can provide great examples of both woodworking and fabric design. The key is to figure out how to make the furniture look as inviting and cosy as possible, and then work on some of the intricacies.

I've tried to make the cushions on this fabric-covered armchair feel almost like clouds at first, and then worked on the pattern with gouache.

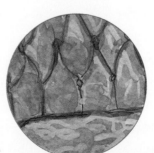

Pay attention to the light source, as the pattern must obey the same lighting laws as the rest of the cushion.

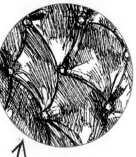

With this leather button-back chair, try to focus on how the cushions burst out between each button. You should almost be able to hear the squeak of the leather in your head, as if you were shifting around on the chair yourself.

For chairs made entirely of wood, work on the curves and shapes of the legs and back first, and then give them the shading necessary to make them three-dimensional. If you can get the light source down first, the rest of the lines will be evident without becoming confusing.

Start with a long line leading into an almost triangular shape.

Make sure that the bristles on the brush are all clumped together in circles that form a rectangular shape along the plastic edge.

This duster needs to have loose feathers, but they must still have a sense of rigidity.

Add in some of the horizontal wiring. To show how tight it is, make the edges of the broom handle between the wires slightly puffed out.

To make this duster look as if it's been through a lot, add some loose hairs right at the handle, and darker values as the feathers start to thin out. The harsher the lines are in these areas, the tougher this will look.

Don't try to render every single strand of this straw broom. Note how the bottom of the broom has a rough-looking edge, and focus on that.

DRAW
THESE
Nos 172-175

Cleaning it Up

There are a lot of great marking methods you can use to render cleaning tools. The main thing to remember is that these tools must look tough, so your marks must be strong, even if they are flowing or loose.

For the shop vac, start out by drawing the basic shape. I began with a curvy 'N' shape and stopped once I got to the vacuum itself. There I drew a cylinder for the outside, with a few squares for the wheel wells.

The trick here is how to render all those rings in the vacuum hose. It takes a while to get all of the circles in there, but if you keep circling around like a Spirograph, it'll end up looking much better in the end.

Pattern and Movement

As with drawing the human figure, it's good to start with a gesture drawing to really get a feel for the full pose. Note how the locomotion of the cat's right leg affects the movement of the front of her body.

Patterns can be used to enhance any composition. The trick is to find a way to get the symmetry right, and then to allow enough space for everything to breathe. The strongest patterns you'll see in design have found that balance between complexity and simplicity.

With this rug, there are a lot of small design elements – but start by breaking the design down into rectangles, circles, diamonds and squares. Once you get those larger areas down, start looking for rhythms. See if a certain pattern is mimicked on the opposite side. Once you get a hold of that rhythm, you can start adding in the smaller details. Don't get too carried away, though – you don't want to lose sight of the bigger picture.

Speaking of pattern, look who decided to relax on the rug. Our cat, Mumbles, has quite an interesting coat of fur and, although the pattern is a bit scrambled, there is another kind of rhythm to take note of in the way she moves. Here are some sketches to study the range of movements she makes.

Or how she moves her tail to balance herself as she reaches upwards. Take note of these rhythms to capture movement of any kind. Cats can be great subjects for this – if they want to.

Start by rendering the sphere and cylinder shapes, beginning with the head, torso, legs and base. The arms are a combination of cylinders and spheres, and the hat is a cone lying right on top of the head. It's details such as this that really make this look like an ornament-sized nutcracker.

DRAW **THESE** Nos 178–187

10 Ornaments

The tiny details in your favourite ornaments can present an interesting challenge. For one, these decorations are already tiny, so they must be rendered in a manner that stays true to their scale.

The challenge with this glass ornament is that it's transparent and has some organic material inside. So thinking back to the transparency work from our refrigerator, you'll want to make sure that there aren't too many solidly defined areas, and that there's softness around the edges.

With this stein of beer decoration, try to show how the ornament's designer placed fake foam on top, and draw those hard lines along the edge to emphasise this point. Any deliberate marks like this will help it look more like a toy.

This ornament is spherical, but features a crater-like divet. Capturing the concave nature of the object all comes down to the shading.

This circular bell has a great metallic colour. Start by colouring this in an almost greenish orange, then add more yellow and white to make the highlights seem golden.

Drawing a chess set gives you the opportunity to draw the same elements repeatedly from different angles and different positions on the board.

For the basic shape of the knight, start out with the oval of the base and then work your way up towards the top. I sketched in a line coming straight up from the centre of that oval to make it easier to judge the correct position of features such as the ears, and to see how much of the figure sticks out beyond the base of the piece.

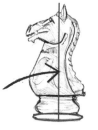

DRAW **THESE** Nos 188-189 Your Move

Note how much more subtle the changes in value are on the white chess pieces: it's still obvious that some areas are in shade, and therefore darker, but the contrasts are far less dramatic than on the black pieces, where there are very obvious highlights along the sharp edges.

With these playing cards, try breaking the values up into sub-groups to make everything easier. Even though there are lots of colours in the face cards, you're sketching them in monochrome – so try to sort each card into light, darker and darkest tones. Simplifying the values from the outset will help you in the long run. Now you just need to work on that poker face...

House of Cards

With the Queen of Diamonds, start with a 'Z' shape going down the centre, and then mirror every mark you make based on that centre line.

Turning colours into monochromatic values is always tricky, so the key is to assume that the most vibrant colours will be lighter in value, and the deeper, more opaque tones will be darker.

DRAW THIS No 191 Distracted Subjects

The easiest way to find someone to pose for you is to look for figures that are distracted. When someone may be involved with a book, their smartphone, a TV, a pet or a craft, they won't move much at all – and if you're slick enough, they won't notice you drawing them!

This example is from a living-room set-up, but you can try this on a train, at an airport,

Notice the curves of the children's backs and the angle of the backs of their heads. It's almost a sharp curve, and this helps you understand which way they're looking, even though you can't see their faces.

When shading folds in clothing, it's best to look for lines and shapes in the clothing that mirror the contours of the figure, and to mark those lines with lighter shading at first, as opposed to hard line edges.

in a park or anywhere there may be people enjoying their leisure time.

The key with sketches like this is that, since you have no idea how long your subject will be seated, you must get a quick gesture sketch down. Think of this 'foundation' as the most important part of the drawing. If the subject is wearing a bizarre hat, or sunglasses, or has wild hair, you should get that information down within the first minute of drawing. That way, if they do move, at least you've got that info down. Think of yourself less as a spy, and more as a journalist.

This wide angle helps to capture the relaxed pose of the figure. Notice how the gentle curve from his right arm flows into the grip he has on the remote.

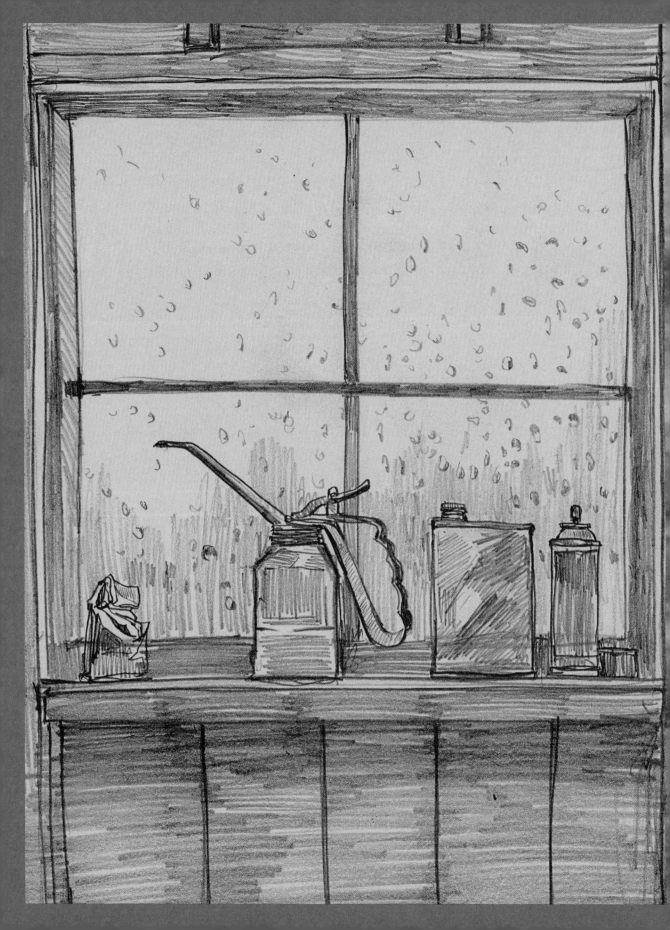

In the
Garage

Your garage may be housing a bicycle or a car, but it's also probably filled with rusty tools, gardening equipment and bugs. Whether loved or loathed, we'll learn how to capture each subject accurately.

A lot of rust and gunk has built up on the handle and on part of the top of this adjustable wrench. I first sketched the tool out in pencil, then added gouache paint to create the metallic look.

Garage Tools

The nice thing about finding tools to sketch from your garage is that you'll probably have a mixture of some that are in pretty good condition, and others that have seen better days.

I achieved the brownish colour by mixing dirty water and all of the colours on the palette. Add that colour on top, using a lot of water. Letting the water dry will help give it that nice, organic, worn-down look. If you want to make the rust thicker in certain spots, just repeat the process.

This plane needs some two-point perspective to make it look accurate (see pages 24–25), so begin by creating the base using the right corner of the plane as a starting point. The shape is almost wave like on the outer right side, so sketch that in and then drag the lines towards the vanishing point to help give the tool some depth. Add value using directional lines to indicate the light source.

Sketch the various shapes within the handle in with ovals and curves, and then add vertical lines to provide some depth. The contrast between the thickness of the handle and the thin metal will help the texture look credible.

Focus on the saw's shape and values. Make a triangular shape that meets the bizarre handle design.

When shading the metal, keep all the lines heading in the same direction.

The trick is to give the corkscrew's wooden handle some depth, and to make the metallic screw look as if it's twisting. Treat the handle in a similar way to a cylinder when it comes to shading. For the screw, try to follow that outer metallic shape like a tether-ball rope going around a pole.

Add the rust in the same way as for the adjustable wrench.

This wood-carving tool is almost a mirror image of itself in terms of shape. The difference appears in the depth of the handle end, and the metallic nature of the tool part. Right where these two parts meet, dark lines and shadows help mark where one form ends and the other begins.

With this pipe wrench, start by drawing out an oval that leads down into a long, rectangular shape. Add some vertical lines to make each of these shapes a bit more three-dimensional. Then, add in the teeth on the head, and make sure they appear correct in space by adding more lines and values.

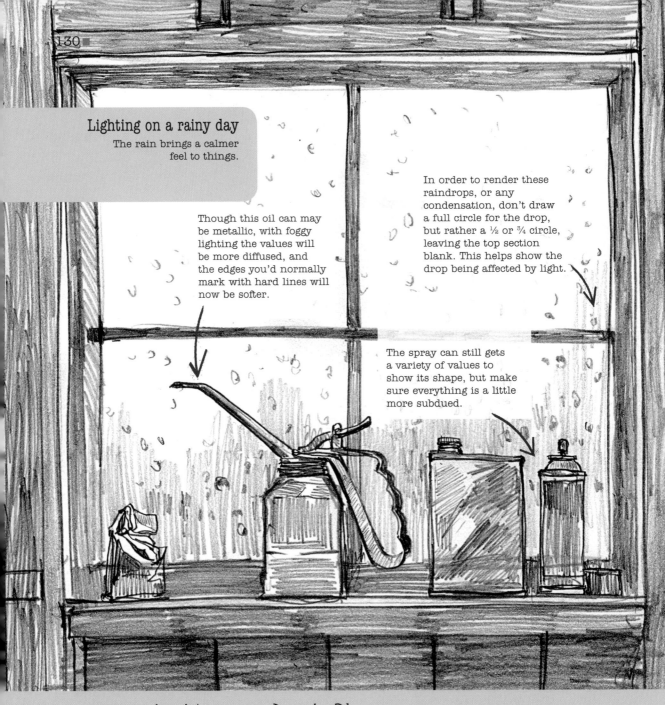

Lighting on a rainy day
The rain brings a calmer feel to things.

Though this oil can may be metallic, with foggy lighting the values will be more diffused, and the edges you'd normally mark with hard lines will now be softer.

In order to render these raindrops, or any condensation, don't draw a full circle for the drop, but rather a ½ or ¾ circle, leaving the top section blank. This helps show the drop being affected by light.

The spray can still gets a variety of values to show its shape, but make sure everything is a little more subdued.

Lighting in Dark Places

DRAW THESE
Nos 202–203

Adding a solid light source is key to any composition. It can take the flatness of any drawing and give it the three-dimensionality you want for a more realistic picture. You'll also want to learn how to control the intensity of such light, and a good way to study these effects is through a window. Artists like Vermeer were masterful at these studies, and you can stage a similar composition right at home.

This cobweb is certainly more visible during a sunny day. Make long, slightly curved lines that begin on the left side and move towards the top of the window frame. Try making marks that are strong and then lighter.

This canister is mostly in shadow, but the subtle halo effect on the top and along both sides helps convey the strong light from outside.

This paper bag is much darker under these lighting conditions, except for the top folds, which have some great diagonal marks that are hit with some extreme contrast.

I've set up this still life with an oil can and spray cans in the garage, and have sketched one setting with lighting on a rainy day, and one on a brighter day. Note the harsher light and contrast from the sunny day, and how the rain brings a calmer feel to things. It's intensity such as this that can really help you control the mood of your art.

Watering Down

DRAW THIS No 204

This watering can presents a challenge: creating a rendering that seems both plastic and lightweight. There are plenty of shapes we can work from to build up the structure, but it's all about how the shapes morph into one another, and the types of mark-making that accompany each plane. Marks that are parallel to one another help make the material look smooth, but also pay attention to the line work where one shape meets another.

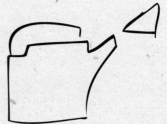

The body of the can is like the shape of a rotated comma, and that shape then protrudes out more until it turns into the cone of the spout. Add on the lower-case letter 'n' for the handle and you're nearly done.

Once you have the shapes, start adding shading to make sense of the flat outine. Here you can see highlights, midtones and deep shadowy interior, which gives depth.

Try drawing this watering can from a few different angles. Don't forget to empty the can out for the severe angles!

When the can is lying on its side, the best way to show depth is with the body itself (think of a rectangle using two-point perspective). The marks made on the handle and sides demonstrate that depth as the marks go with, as opposed to perpendicular to, the plane.

Use the comma and cone shape as a starting point each time.

Step 1: Start off with a few circles for the wheels and pedals, and then a triangular shape for the frame. I added a small curl for the handlebars, and a line to insinuate where the seat would go, too. Note how the pedal gears are essentially the centre of the bike, and the triangle really leans the weight towards that point.

Step 2: Next, add some thickness to the wheels, frame, seat and handle bars. I've also put in some of the details on the brakes and pedals, but at this point I want to make sure the frame looks pretty solid before moving on.

IT'S LIKE DRAWING A BIKE

DRAW
THIS
No 205

Any bicycle owner knows how to ride one, but getting familiar with all of the gears, derailleurs, cranks and tubes is another thing altogether. Drawing a bicycle can present similar challenges: it's fairly easy to see how to start off a drawing, but it's all the details that really make the finished rendering stand out.

Shade the tyres to make them darker, and add some shading to the frame to help it pop more.

Step 3: Put in some tonal values on the tyres and frame. Add a chain to the pedal gears, and note the path the chain takes as it zigzags through the rear derailleur. Add in some of the detail to the pedals and the front derailleur as well.

Step 4: Push the values even further by darkening lines at the connecting parts of the bike: the seat to the frame, the handle bars to the valves, and the brake pads to the wheels. Add some shading to the seat, using lighter marks to imply its softness relative to the metallic nature of the frame.

The spokes almost look as if they make a U-turn around the centre, and then head back towards the rim.

My bike has 37 spokes – not that anyone will count. But if you want a solid critique on this drawing, I'm sure your local bike mechanic will be happy to give feedback!

From a side view, a skateboard is nearly flat, with its ends arching slightly upwards. The wheels lie beneath, right before that arch, and underneath the 'trucks'.

Skateboards

A skateboard has a simple enough shape, but the most interesting aspects are definitely the graphics on the back and the designs on the wheels.

This is a good example of two-point perspective, although it's not so easy to see with the board's rounded edges.

Vanishing point

Start your perspective lines from the tops of the wheels, and from the edges where the trucks meet the board. From there you can build the skate deck shape, making a subtle arch to round it out rather than giving it hard edges.

In many cases, painting the graphics means that you'll be working with vibrancy and glossiness. With this skull design, the pink transitioning into the yellow is a fairly obvious aspect, but to make the board appear three-dimensional, you'll need to add some darker and more muted values at the top and perhaps at the bottom.

For the vibrant pink, add more white and even a little more yellow.

Add some darker and more muted values at the bottom.

Add some darker and more muted values at the top.

Add blue and some yellow to mute the pink.

Vanishing point

To transition to the yellow, keep slowly adding some yellow to your mix of pink, and apply the paint almost in stripes to help you achieve that gradated tone.

Dirty Work

Gardening is good, messy work, so let's get a little messy with this one. Sometimes it's best to just sketch in broad strokes without worrying too much about the outcome. When you draw with a nib pen and ink, as in these exercises, there's no erasing and you have to live with the marks you make. The trick is to be okay with this – and being okay with some flaws will inevitably help you to loosen up and draw in a much freer, more spontaneous way.

Use a nib pen and just go for it. You can be as simple as you want – and in the early stages, the simpler, the better.

Use a couple of quick
lines that cross over to
start things off – think
of a gradual curve for
one handle and blade
and an elongated 'S'
for the other handle
and blade. Try just using
contour lines to really
illustrate the tension
caused where these two
parts cross over.

This moth may be ugly and unwanted if found in your clothing, but on its wings there is actually quite a nice pattern. Notice how one side is a mirror image of the other, and how that pattern helps it blend into its environment.

DRAW
THESE
Nos 211–220

Creepers in the Night

They're unwelcome in your home, so you'll find them in your garage, hiding in corners, and often keeping completely still. These many-legged insects serve as great examples for rendering bizarre creatures that strike a sense of fear and disgust just by looking at them. You'll want your drawings to measure up to that same level of disdain, as undesirable as that may be.

This earwig has a shape almost like a bottle opener, with its pincers being the most prominent feature. Notice how each of the segments has a different sheen and pattern, and how the segmented sections near the tail help you imagine the movement they may make.

With a crane fly, notice how the six legs and wings almost explode out of the centre of its body. The legs also have a slight curve at each point, as they fold inwards to help provide a sense of their weight.

This ant appears to walk tenderly, and a lot of that is due to the fact that its legs curve softly to the ground, and you can also see its eyes fairly well.

The black widow is the most unwelcome of insect guests, and can be deadly. You can understand this by its long legs which almost come to a point at the end. If you can't find one, just go online instead, please.

This earthworm has an inconsistent thickness, with segments all the way around. These bulges and awkward curves help make it look gross, as it should.

This woodlouse, or rollie-pollie if you prefer, has a segmented body similar to that of an armadillo, and it also has a lot of gloss on its outer shell. Notice how the highlights are more striking and the shadows are deeper as you meet curves and divets along the shell.

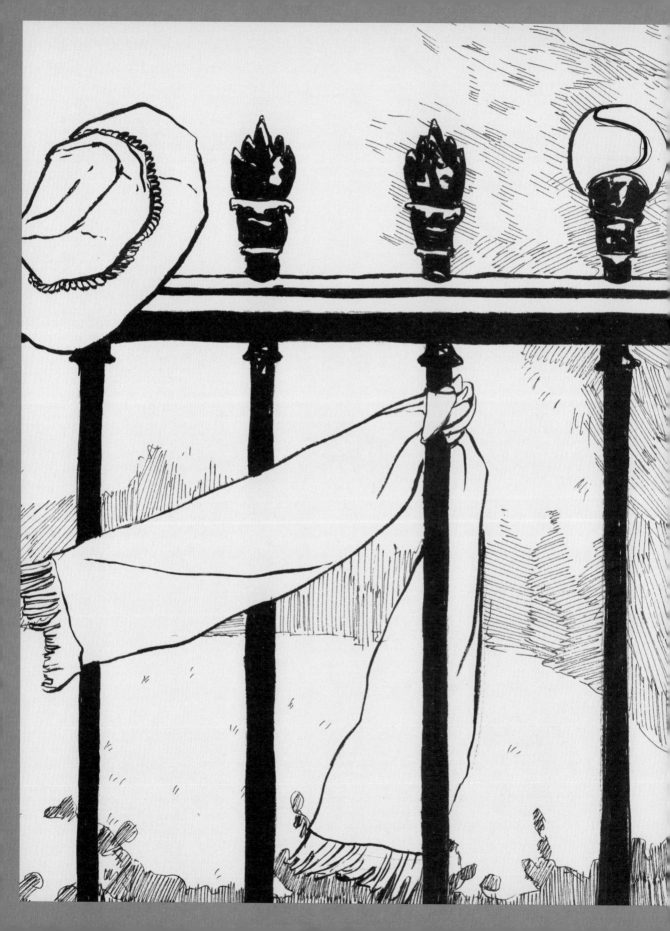

In the
Street

Going outside to draw is the best way to document life. The buildings and street signs may be fixed in place, but thanks to the changing seasons and conditions, you'll never be able to draw the same view twice.

Urban Drawing

DRAW THESE Nos 221

Drawing outdoors is one of my favourite ways to relax. I look at the process as a means of capturing a moment in your life, and in your town's history. You're a journalist in this regard, so the idea is to truly capture how everything actually looks, as opposed to ideals. Real cities feel lived in, so it's important to sketch in all that you see.

When this guy was crossing the street, I obviously had very little time to draw him, but I felt that he added more life to the drawing, so I added more detail to him closer to the end.

This scene has some fairly straightforward two-point perspective, which is the best place to begin. The horizon line is at the eye level of the fellow crossing the street, and on the far left and far right corners is each vanishing point. You can follow the lines from the pavements and buildings to either end, and the centre building shows sides going towards both corners.

Eyeline

It's okay to leave parts unfinished – sometimes it helps make your drawing feel fresh and alive!

To build the major shapes of your drawing, begin by adding the cylindrical building on the left and then add the rectangular shapes of the other buildings before moving on to the awnings and the cars.

Once you have fleshed out the shapes in your drawing, you can then start adding in some shading for the trees, and shadows on the windows and cars.

Start by rendering the overall shape and the veins and stem inside the leaf. Then add in some of the darker colours before moving to the lighter tones. The colour on this leaf is very inconsistent, so work on the broader areas before adding every small detail.

Draw the stem of the maple leaf first, all the way to the tip of the leaf. Then add in some rectangular shapes, almost in the shape of a '+', so that you can see the foundation for the rest of the leaf. Now you can add in some of the more subtle curves and spikes to create the rest of the silhouette.

A palm leaf looks incredibly complex, so try not to go insane. Establish the overall fanning shape first, then work on each individual thin section. It'll be worth it in the end, trust me.

10 Leave it Be

DRAW **THESE** Nos 222-231

To study leaves is to study the brilliance of nature. Some are symmetrical and delicate, while others are so thick that they could survive anything the elements throw at them. The key is to put down any obvious symmetry and pattern first, and then deal with all the other information.

Start by drawing out the simple shape of this eucalyptus leaf and putting in its overall reddish hue before adding in the darker brown blemishes.

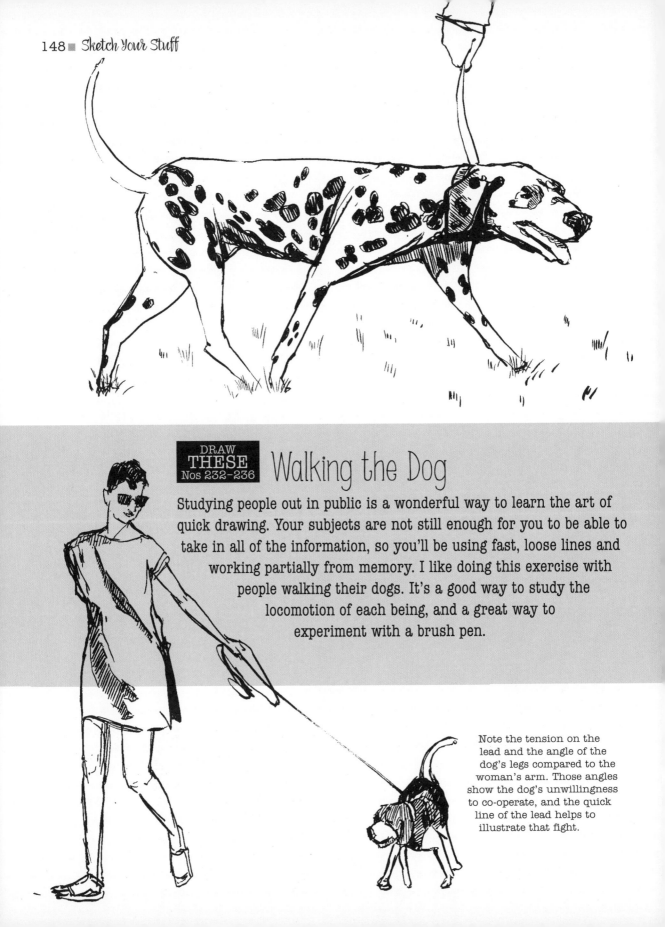

Walking the Dog

Studying people out in public is a wonderful way to learn the art of quick drawing. Your subjects are not still enough for you to be able to take in all of the information, so you'll be using fast, loose lines and working partially from memory. I like doing this exercise with people walking their dogs. It's a good way to study the locomotion of each being, and a great way to experiment with a brush pen.

Note the tension on the lead and the angle of the dog's legs compared to the woman's arm. Those angles show the dog's unwillingness to co-operate, and the quick line of the lead helps to illustrate that fight.

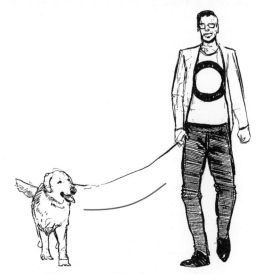

This woman and her dog are jogging right at us, and there are plenty of dynamic lines to illustrate this.

This man and his dog are walking towards us at a calm pace, which is evident in the loose, curving lead and his casual-looking gait.

Note the angle of her legs in relation to the dog's, and how there is tension in the lead. The dog seems to be running and pulling away slightly from the lead, which is why its legs are heading back towards her.

This fellow and his black lab are strolling more casually, as we can tell by his walk and by the jaunty, carefree angle of the dog's tail. There seems to be no rush here.

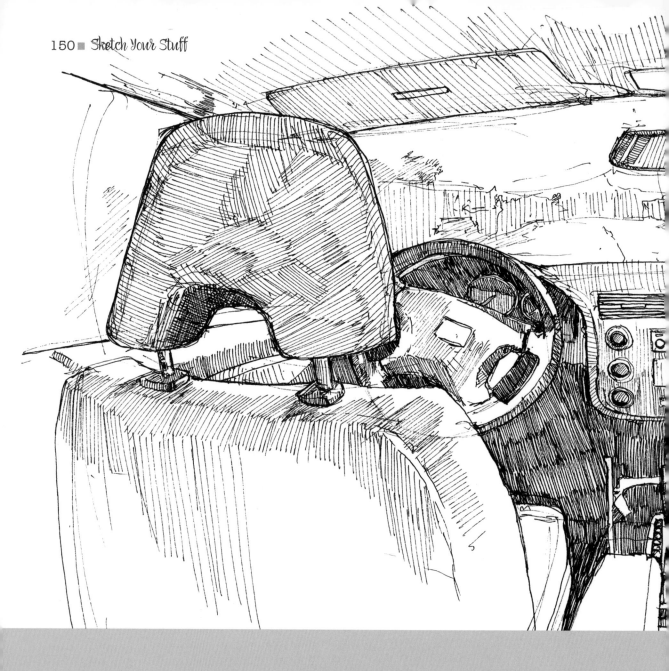

Backseat Driver

DRAW
THIS
No 237

A great way to improve your skills in regards to one-point perspective is to study from within an enclosed space. It's tougher to see the vanishing point, but you'll have an easier time seeing the severity of the angles. From the backseat of the car, you can see how all the lines along the edges of the seats, the top of the car, the centre console and the dashboard recede into space.

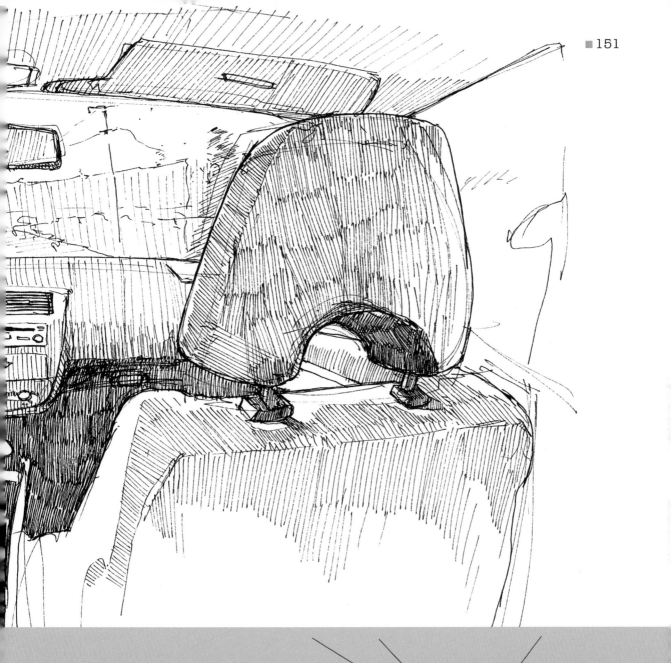

Imagine the vanishing point lies on the horizon line above the dashboard, almost in the centre of the bonnet of the car, and that virtually all the lines end up going directly there. Also note how the scale of some of the objects and some of the objects in the distance can help to create the illusion of depth and distance that you're going for. Now for a real challenge: try drawing on your next Uber ride.

Horizon line

Don't worry if the perspective lines are not perfect: it all adds to the immediacy and liveliness of your drawing.

DRAW
THESE
Nos 238-245

Fire Hydrants - There if You Need 'Em

I've always loved drawing fire hydrants. For objects that are almost designed to be hidden, they really do come in a wonderful variety of shapes, colours and sizes. Each hydrant has a similar anatomy, but the challenge lies in making each one look realistic in its material and function.

This hydrant has a clean, almost wet, look. This smoothness is captured by vertical lines that shade the shaft of the hydrant.

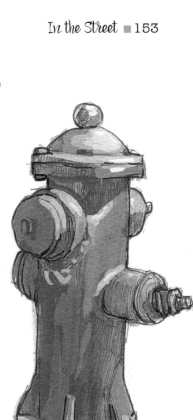

Then within that first cylinder, add one or several perpendicular cylinders for the hose nozzle(s). Notice how this first cylinder fits over the base, and then morphs into an almost conical shape in some cases.

To capture the appearance of the matte surface on top I used some thicker gouache paint with minimal highlights. If there were any very bright highlights, this would seem too glossy.

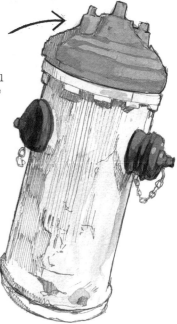

The nozzle sleeve has a lot of rings, so add those in, and don't shy away from adding colour if there's a great hydrant in your neighbourhood.

I Draw the Sign

Street signs and traffic lights are essentially a lot of basic shapes all combined together. No doubt you'll get a lot of attention sketching out in the open – just make sure you stay clear of the road.

DRAW THIS No 246

TRAFFIC LIGHTS

When sketching traffic lights, start with a flat rectangle and then, depending on the angle, treat the horizontal lines as either flat or angular. Next, stack several cylinders on top of the rectangle for the light housings.

The light itself lies within the cylindrical housing, so remember to show a more reflective material in this area. If it's lit up, make sure you illustrate that light source.

Don't forget to add in a lot of darker values to show the light housing's depth, too.

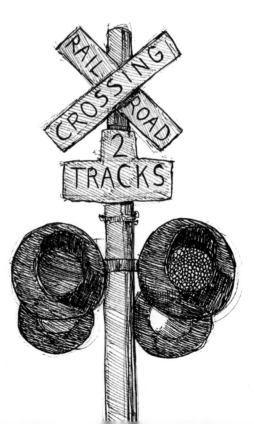

MANHOLE COVERS

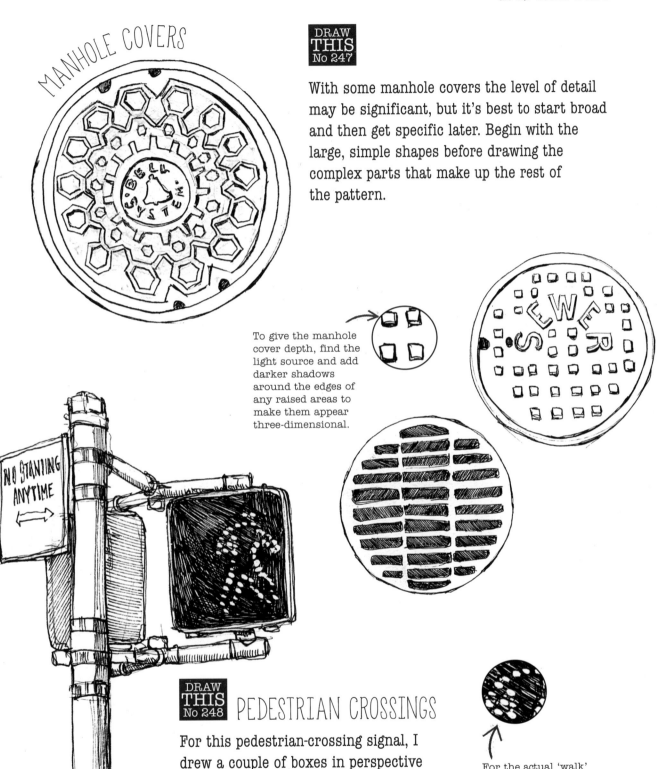

With some manhole covers the level of detail may be significant, but it's best to start broad and then get specific later. Begin with the large, simple shapes before drawing the complex parts that make up the rest of the pattern.

To give the manhole cover depth, find the light source and add darker shadows around the edges of any raised areas to make them appear three-dimensional.

DRAW THIS No 248 — PEDESTRIAN CROSSINGS

For this pedestrian-crossing signal, I drew a couple of boxes in perspective first, along with a thin cylindrical line for the pole.

For the actual 'walk' image, I dotted white gouache over a black backdrop.

Think about thickness of line and contrast. You want the objects on the railings to be prominent, so make sure they have strong, thick lines and more contrast than the background. They'll need a little more attention to detail than the railings.

DRAW
THESE
Nos 249–253

Objects on a Railing

You can use this exercise as a means of understanding perspective by illustrating depth. When you look at objects left behind on a railing, you see a scene that contains the objects themselves, the railing, and perhaps some other planes in the foreground. As we can also see beyond all of the railing bars and the objects, you'll also need to add a background of some sort that does not create too much of a distraction.

When working on the railings, you want to handle the lines and dark values in a similar way to the glove, but don't get too carried away with the details. You don't want the railings to compete with the objects.

For the background, you want an almost hazy effect: avoid harsh outlines and use lines that don't cross over each other. Use a fine-point pen for the best results.

Index

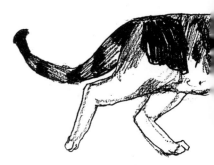

Credits

Quarto would like to thank and acknowledge
the following for their contribution to this book:
cat_arch_angel/Shuttertock.com p.35
clocki/Shutterstock.com p.123
elbud/Shutterstock.com p.67
Elovich/Shutterstock.com p.110t
George Baker p.9
Mary Rice/Shutterstock.com p.152
Zebphyr_p/Shutterstock.com p.110b

All step-by-step and other images are the copyright of Quarto
Publishing plc. While every effort has been made to credit
contributors, Quarto would like to apologise should there have been
any omissions or errors – and would be pleased to make the
appropriate correction for future editions of the book.

Author acknowledgements

For my family and friends, without
whose unconditional support this
book could not be realised.

Jon